THIS IS A CARLTON BOOK

Manufactured under license from Revlon.
© 2003 Carlton Books Limited and Revlon®

The product names ColorStay Overtime™, LipGlide™, ColorStay, Stay Natural™, Illuminance™, Always On, Wet/Dry, Sleek Cheeks, Super Lustrous, Super Top Speed, Timeliner, Moisturous™, Skinlights Color Lighting™ and High Dimension are registered trademarks of Revlon. All 'Revlon' logos are registered trademarks of Revlon.

This edition published by
Carlton Books Limited 2004
20 Mortimer Street
London W1T 3JW

ISBN 1 84222 678 5

Printed and bound in Dubai

Editorial manager: Judith More
Executive editor: Lisa Dyer
Art director: Penny Stock
Designer: Zoë Dissell
Contributing writer: Lisa Dyer
Production controller: Lucy Woodhead

Special Photography
Photographer: Elizabeth Young
Producer: Gayle Dizon
Fashion Stylist: Samira Aboul Nasr
Prop Stylist: Stockton Hall
Casting by: Jennifer Venditti Inc.
Makeup: Molly Stern and Liza Zaretsky
Manicurist: Gina Viviano
Hair: Nelson Vercher

Special Thanks
Rochelle Udell, Kerry Bernstein, Steven Brinlee, Mariah Kulp, Michael Miller, Bob O'Connell, Gloria Pflanz, Jennifer Schorr, Marty Stevens, and Martine Williamson.

ULTA
SALON · COSMETICS · FRAGRANCE

unforgettable color

MAKEUP WITH CONFIDENCE

Selene Milano

REVLON®

Contents

The Colors

Foreword

This is not about fashion. It's not about style. This is about the **primal**. The visceral. The **irresistible**. This is about **color**.

What you think. Right now. What you imagine. What you see. Is profoundly driven by color.

It does not speak. It does not smell. It does not feel. But it can seduce. That's the nature of color.

In its purest form, the spectrum is quite limited. Red. Yellow. Blue. But introduce them to each other, mix them up, and you've changed how you see the world. Each of us knows color in the most basic sense. Each and every day we assume the social influence of a color and make it part of our personal communication.

One day it's red—Assertive. Sexy. Confident. Passionate. The center of attention. The next, a cool shade of blue—Relaxed. Chilled. Understated.

We call these lovers of color "Passionistas."

As we smile, laugh, walk down the street, we don't register it as a conscious thought. We perceive it on instinct. And we respond the same way, using the most fundamental level of emotion. As if some unrecognizable piece of our genetic makeup responds to color. Passive. Aggressive. Thoroughly indecisive or passionately decided.

Color cues determine what makes us most physically appealing to each other. What can push someone away, or bring them near. It's an unspoken language that influences desire, hunger, sleep and awake. It tells us who we are. Pink is for girls.

Blue is boys. So is brown. You can become green with envy. Jet into the wild blue yonder. Have a yellow streak. Call the kettle black.

Colors come in and out of fashion, but they never go away. They are always here, always visible, despite the social or political mood of the moment.

This constant influence of color and how it affects beauty is where color cosmetics come into play. Your personal statement is influenced by color or the lack thereof. That fascination with color and how it makes us feel is what drives Revlon's obsession with color.

This idea is nothing new. In fact, more than 70 years ago Charles Revson's passion for color led him to create the first nail enamel using true color pigments for richer, shinier nail color. His passion led him to suggest and encourage women to coordinate their lipstick and nail color for a complete beauty look. His belief was that color allows women to express who they are and how they feel. And women responded in droves with their own passion for Revson's colorful, shining, playful cosmetics. The reds, pinks, tans—bold, soft and every shade in between—enabled them to

be who they wanted with confident beauty. Suddenly, they had been given keys to the proverbial candy store, and it was delicious.

Today, this passionate love affair with color is more apparent than ever. In Revlon's product offerings. Revlon's advertising. Revlon's celebrity spokeswomen. Each one embodying the idea of color and its positive impact on the world. Without it, life would be bland. Boring. You may as well turn out the lights.

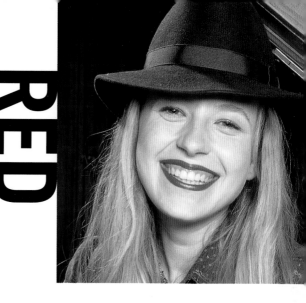

RED

Introduction

Color plays such an extraordinary role in our lives. It's the background and the focus. We use it to describe our strongest emotions—fear, love, jealousy, and sadness. When something is seen in bright Technicolor, it's vibrant, breathing, singing, and bigger than life.

This book is an inspirational and practical guide to using colors in cosmetics to express your mood and highlight your natural beauty. Color in beauty is about enhancing the way you feel, as well as the way you look. By examining the symbolism of and the universal elements associated with each color, the book shows you how color informs your ideas and affects your well-being.

Many derivations of color, tone, hue, and saturation lie in nature, and the colors we see around us are sources of inspiration for how we can use color in our daily life. The book is divided into seven color chapters, each of which includes basic beauty advice, step-by-step applications and treatments, tips on using cosmetics and color, and analysis of how makeup colors work with different skin tones and hair colors.

Included are profiles of seven vibrant, beautiful women—mothers, artists, musicians, and career women—all of whom epitomize the independent spirit of Revlon. Here they share personal stories of their lives and experiences, as well as their ideas about beauty. These women perfectly exemplify that beauty is not set in stone—it all depends on the personality and character of the woman herself. So we encourage you to experiment and find the techniques and shades that work best for you.

Beauty holds such an intimate connection with women, and this book is a celebration of that connection. We hope it makes you feel pretty from the inside out. Enjoy!

CORAL and
ORANGE

YELLOW

BLUE and
GREEN

PINK

PURPLE and
LILAC

NEUTRALS

Revlon

1932

REVLON®

today

For over 70 years, Revlon has maintained a name synonymous with vibrant, exciting, sexy, and above all, colorful cosmetics. Truly an American icon, Revlon has continued to lead the way in technological innovations in color cosmetics and has built a brand for bold women who are passionate about beauty. Recognized and sold in over 175 countries, Revlon was founded in 1932 by Charles Revson and his brother Joseph, along with a chemist, Charles Lachman, who contributed the "L" to make the name Revlon. The company had modest beginnings, in which all three founders pooled together their meager resources and created a nail enamel unlike any before it, using pigments instead of dyes for added opacity, shine, and wearability. This process allowed women to have rich-looking nail enamel in a broad spectrum of shades never before available. Within six years of its inception, Revlon became a multimillion-dollar company. Today Revlon leads the cosmetics industry in technological advances and continues to represent the modern woman's ever-changing beauty needs.

Revlon **Firsts:**

1930s: The company began its success with pigment-based nail enamel sold through beauty salons, then on to department stores and select drugstores.

1940s: Revlon contributed to the war effort by manufacturing first-aid kits and dye markers for the U.S. Navy. By the end of the war, Revlon diversified their range and was producing manicure and pedicure instruments.

1950s: The legendary Revlon advertisements, showing glamorous women that encapsulated the time period, began to circulate. Twice yearly, lipstick and nail enamel promotions, linked to seasonal fashion statements as well as television sponsorships, boosted sales.

1960s: Revlon launched The American Look campaign, which featured U.S. models, to the rest of the world, positioning Revlon as an all-American brand and the last word in style.

1970s: The fragrance *Charlie* took the world by storm. Named after Charles Revson, *Charlie* was designed for the young, working woman, and in only three years the perfume surpassed *Chanel No. 5* as the number-one fragrance in the world.

1980s: In 1984 Revlon became the first to introduce mix-and-match makeup components with their Custom Eyes. Advances such as Firming Eye Gel, One Coat Application nail enamel, and silicone-based makeup were added to the Revlon roster. In 1987 the legendary Unforgettable Women campaign was launched and in 1989 Cindy Crawford signed on as Revlon spokeswoman.

1990s: Revlon became the number-one mass color cosmetic brand in the world. The brand was the first to introduce "transfer-resistant" lip color, which led to the ColorStay collection of transfer-resistant products available today.

2000+: Innovation continues with a whole new category of brighteners and the inception of Skinlights, Revlon's exclusive light-capturing complex. Advances in ColorStay carry on, and High Dimension hair color, the first ten-minute permanent hair color, is launched.

Legend has it that in 1939 Charles Revson noticed a woman lighting a cigarette at a dinner party and was turned off to discover that her nail enamel color clashed with her lipstick. It was then that the concept of "matching lips and tips" was born, which still stands to this day. "Matching Lips and Fingertips" marked the first time Revlon ads, like its products, were in full color, and they spread over two pages in

Matching Lips and Fingertips

such magazines as *Vogue* and *Harper's Bazaar*. The ad read: "Pick up a tea-cup, light a cigarette, draw on a glove. Your slightest gesture delights the eye with lips and fingertips accented vitally, fashionably by Revlon Nail Enamel." Revlon's unforgettable invitation to women would forever change the face of beauty advertising. As seen in the following advertisements, it became an integral part of our culture and continues to evolve to meet the tastes of women today.

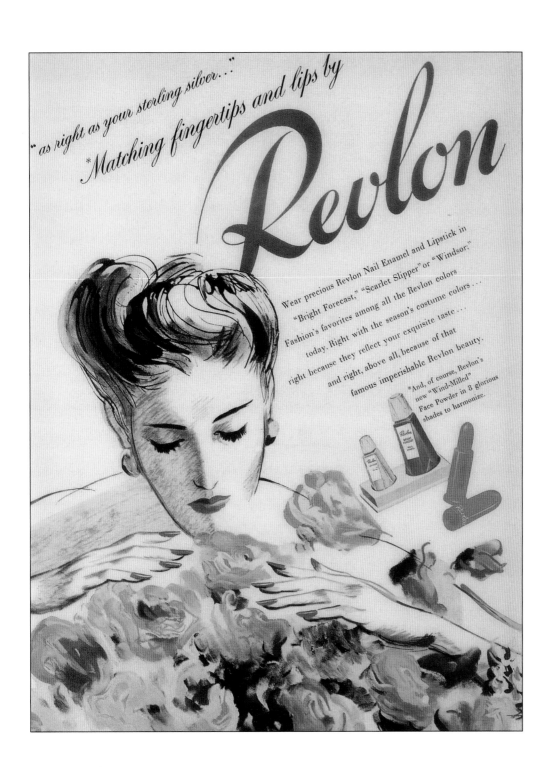

for you who love to flirt with fire...

who dare to skate on thin ice...

Revlon's Fire and Ice

for lips and matching fingertips. A lush-and-passionate scarlet
...like flaming diamonds dancing on the moon!

"Indelible-Creme" Lipstick...Regular Lipstick
Frosted Nail Enamel...
Improved-Formula Nail Enamel

COSTUME: BOVÉ OF ROSE SCHOBEL
PHOTO: AVEDON BING: JOHN P. JOHN

Fire and Ice, 1952

Dorian Leigh, a stunning redhead, was the model for the Fire and Ice ad campaign. Leigh was already a top model when she posed for Fatal Apple, her first Revlon spread, in 1945. From then on Charles Revson was said to have considered her "lucky" and used her in shade promotion after shade promotion.

The ad posed questions to allow the reader to determine whether she's "made for Fire and Ice," like: "Does gypsy music make you sad?" and "Do sables excite you, even on other women?"

Fire and Ice is still one of the company's best-selling shades.

RE YOU

ADE FOR 'FIRE AND ICE?'

this quiz and see!

What is the American girl made of? Sugar and spice and everything nice? Not since the days of the Gibson Girl! There's a *new* American beauty . . . she's tease and temptress, siren and gamin, dynamic and demure. Men find her slightly, delightfully baffling. Sometimes a little maddening. Yet they admit she's *easily* the most exciting woman in all the world! She's the 1952 American beauty, with a foolproof formula for melting a male! She's the "Fire and Ice" girl. (Are *you?*)

	yes	no
Have you ever danced with your shoes off?	yes ☐	no ☐
Did you ever wish on a new moon?	yes ☐	no ☐
Do you blush when you find yourself flirting?	yes ☐	no ☐
When a recipe calls for *one* dash of bitters, do you think it's better with *two?*	yes ☐	no ☐
Do you secretly hope the next man you meet will be a psychiatrist?	yes ☐	no ☐
Do you sometimes feel that other women resent you?	yes ☐	no ☐
Have you ever wanted to wear an ankle bracelet?	yes ☐	no ☐
Do sables excite you, even on other women?	yes ☐	no ☐
Do you love to look *up* at a man?	yes ☐	no ☐
Do you face crowded parties with panic—then wind up having a wonderful time?	yes ☐	no ☐
Does gypsy music make you sad?	yes ☐	no ☐
Do you think any man *really* understands you?	yes ☐	no ☐
Would you streak your hair with platinum without consulting your husband?	yes ☐	no ☐
If tourist flights were running, would you take a trip to Mars?	yes ☐	no ☐
Do you close your eyes when you're kissed?	yes ☐	no ☐

Can you honestly answer "yes" to at least eight of these questions? Then *you're* made of "Fire and Ice!" And Revlon's lush-and-passionate scarlet was made just for you—a daring projection of your *own* hidden personality! Wear it tonight. It may be the night of your lifetime!

29

Cherries in the Snow, 1953

Playing on the dramatic color scheme of red and white, Cherries in the Snow (an uber-successful shade of red that still attracts legions of fans to this day) is a legendary ad.

Does any man really understand you?

Who knows you as you really are? Does he?

Who knows the secret hopes that warm your heart?

Who knows the dreams you dream, the words you've left unspoker

Who knows the black-lace thoughts you think while shopping in a

Who knows you sometimes long to sleep in pure-silk sheets?

Who knows you'd love to meet a man who'd hold your hand and lis
while you say nothing at all?

Who knows there was a morning when your orange juice sparkled

Who knows the secret, siren side of you that's female as a silken

Who else but Revlon understands you as you really are . . .

a trifle shy, but oh-so-warm . . . and just a little reckles

deep inside . . . as strange and unexpected as cherries in the snow.

Revlon's 'Che

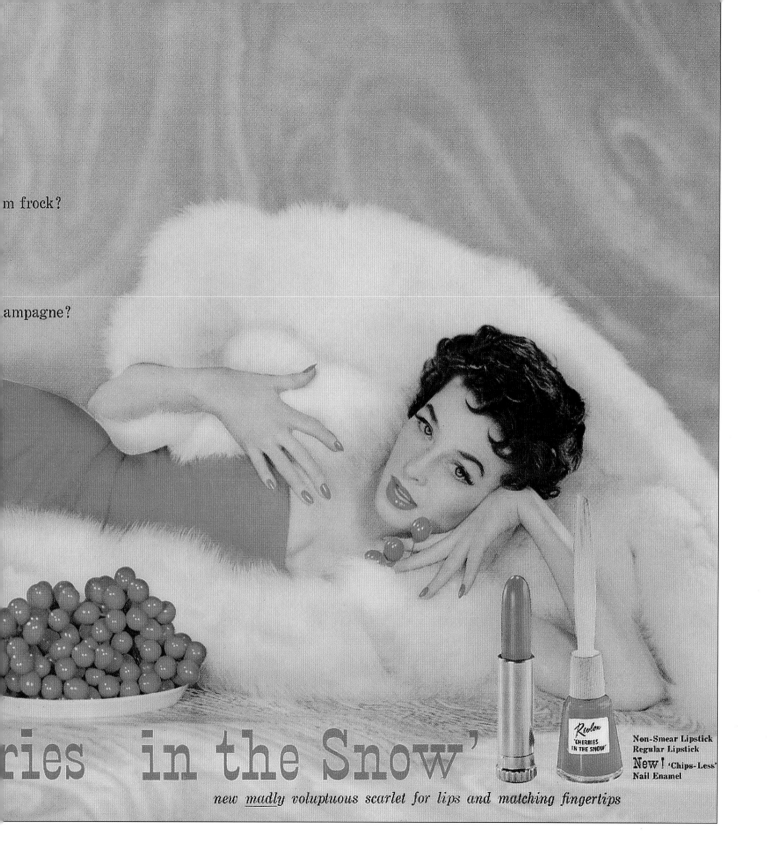

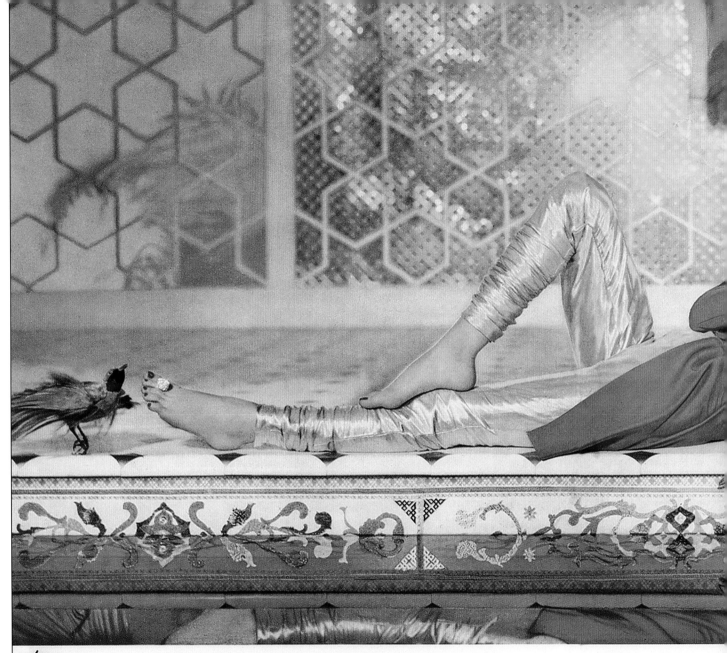

Revlon's new color...

'Persian Melon'

...it's the most <u>delicious</u> shade this side of paradise!

A luscious golde
for

What a *color!* Revlon kidn
a gorgeous golden glow . . .
whatever your hair shade,
'PERSIAN MELON' keeps ma
mer long. So potent . . . it
on 'til the sands of the de

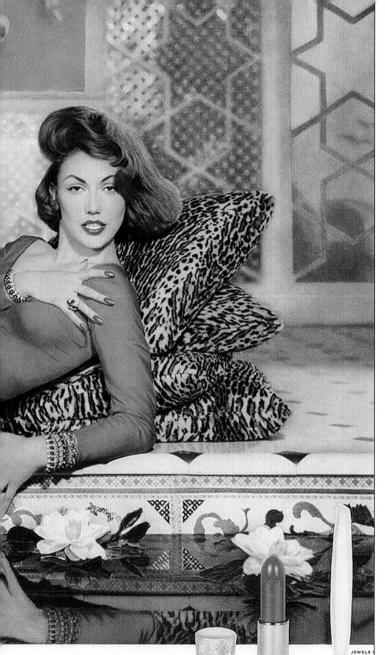

Persian Melon, 1957

Persian Melon reflected an exotic, Middle Eastern feel. Created on a grand scale, the elaborate set featured a water reflection pool, leopard pillows, and tons of luxurious accents and details rarely seen by most Americans at that time.

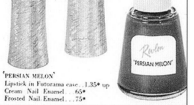

n with a <u>coral</u> flavor

ngertips...and toe-tips, too!

ret shade in the mysterious East . . . gave it
vith *coral* . . . to flatter you outrageously . . .
our skin tone. Positively voluptuous, new
pany with all your heat-wave fashions sum-
onight into forever! (Lasting? Seems to stay
·ld!)

'PERSIAN MELON'
Lipstick in Futurama case . . 1.35* up
Cream Nail Enamel . . 65*
Frosted Nail Enamel . . .75*

Colors Avante Garde, 1961

Colors Avant Garde, featuring model Suzy Parker in a colorful vinyl hat, differed from other cosmetic ad campaigns in that it was the first major multiple color promotion. It jumpstarted the trend of wearing more than one color at once and experimenting with different, never-seen-before shades on the face.

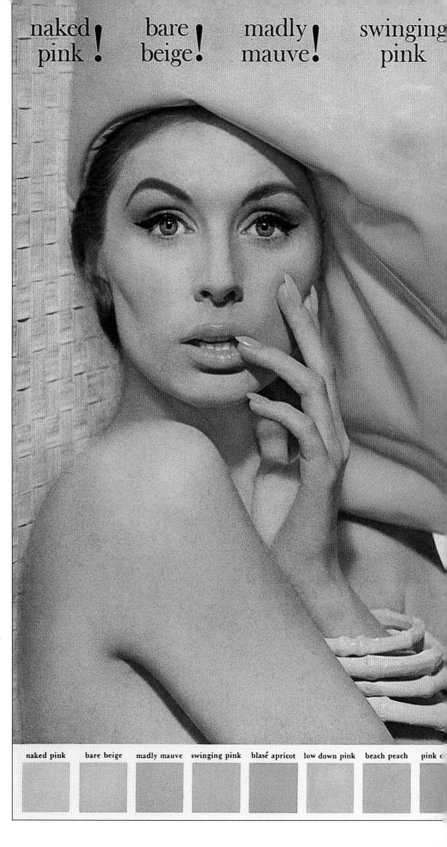

naked pink ! bare beige! madly mauve! swinging pink

naked pink bare beige madly mauve swinging pink blasé apricot low down pink beach peach pink c

blasé apricot! low down pink! beach peach! pink cognito! nouveau peach! super-natural!

Revlon's (not a cliché in a carload)

'colors avant garde'

10 new _potent_ _pales_ for lips and nails!

New _low-key_ _look_ for today's _new_ _breed_ of beauty... bored with yesterday's fashion clichés, restless for tomorrow's look today!

nouveau peach super-natural

Comes the evolution! No harsh or hackneyed reds, no pedestrian pinks! These are _low-key_ colors—so new they're barely born! Sensuously soft. Shatteringly chic. You'll love them on sight. Scoop up Revlon's 'COLORS AVANT GARDE'—all 10 at a clip!

© Revlon, Inc., 1962. Hat by Mr. John

if
looks
can kill...
this
one
will!

The new Cleopatra Loo

▲ the sultry, sweet-lipped, sloe-eyed look that shook the pyra
a sphinx-pink smile are suddenly shockingly chic today...

'Sphinx Pink'

Newest spring shade for lips and matching fingertips!

A vividly light, bright-at-night *power-mad* pink! More
sharp than sweet, more sly than shy . . . chic-est shade
in 2000 Springs! Wildly flattering—wonderfully *wearable*.

'Sphinx Pink': Super-Lustrous D, Lustrous, and Lanolite Lipstick, matching Nail
Enamel, 'Futurama' case by Van Cleef and Arpels for new 'SPHINX DOLL' case')

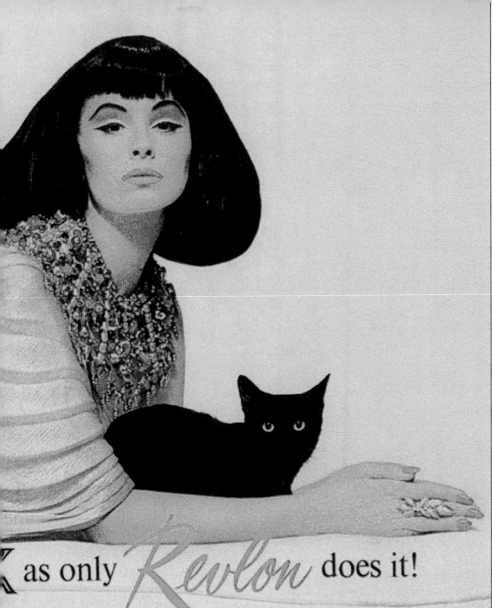

as only *Revlon* does it!

s, shocked the world! see-at-night eyes...
the deadly ingredients (redistilled) are these:

inx Eyes'

eye makeup! Madly mysterious! Egypt-inspired!
shaped . . elongated . . darkly outlined for depth.
lids, lightened with beige, shadowed with smoky
ffect? Unforgettable! (And almost *unforgivable!*)

Desert Beige Accent Shadow, Misty Grey Kohl Eyeshadow, Brown Ash
eliner and 2 applicator brushes. (Available separately, or in complete kit.)

Cleopatra, 1963

Created in conjunction with the movie,
Cleopatra, starring Elizabeth Taylor, this
ad was a major reflection of the look
of the 1960s: black liquid eyeliner and
pin-straight, shiny hair. Suzy Parker, the
model in the ad—and coincidentally
the sister of Fire and Ice model, Dorian
Leigh—wore a black wig and held
a black cat.

rot
rojo
rosso
röd
rot
red
rot
rouge

Our Associations with Color

Red symbolizes energy and action and is associated with power, leadership, short temper, sexuality, and heat. It is a double-edged color—both attracting and signaling danger. The forbidden apple from the Garden of Eden is one example of the enticing quality of the color, and many other luscious, nutritious foods are red, such as berries, bell peppers, and chilies—in fact, red is known to stimulate the appetite. Exposure to the color is also said to speed up the pulse, increase the respiration rate, raise blood pressure, and boost energy.

Energy

- Increase your energy levels by drinking water. Dehydration is a major cause of fatigue, and sufficient water is needed in order to facilitate even basic metabolic processes within the body.
- The key to rejuvenation and better blood circulation is exercise. It's easy to stop exercising when you're feeling sluggish, but forcing yourself to do even a light workout will enable you to keep energy levels elevated.
- Protein supplies energy. For a well-balanced diet, 30 percent of your intake should be from protein. You can obtain this mainly from lean meat, fish, and eggs, but good vegetarian sources are nuts, milk, whole grains, and tofu.
- Practicing a de-stressing technique on a daily basis sets up the relaxation response, which allows the muscles, internal organs, and brain to take a deep rest, resulting in improved energy levels.
- For extra vitality, eat spicy food with lots of fresh chilies, and increase your intake of fresh fruit and vegetables—up to at least five portions a day—because they are packed with immune-boosting antioxidant vitamins and minerals.
- Prevent the classic dip in energy mid-afternoon by having four to five small meals a day rather than one or two big ones. This meal plan will help to keep your blood sugar levels steady and reduce general fatigue.
- Simple sugars, alcohol, and coffee deplete your adrenal glands and have a dramatic effect on energy levels, so cut down on your daily intake of these substances.

Red-Hot Chilies

Fresh chilies can add spice to your meals and a new zest for life. Many people believe, wrongly, that all hot spices are irritants to the digestive system. However, chilies and cayenne have the reverse effect; they are both beneficial to digestion and actually soothe the stomach. Since ancient times, chilies have been used by healers to cure a variety of ailments. A single pepper has been found to contain a full day's supply of beta-carotene and nearly twice the recommended daily allowance of vitamin C, which makes the chili an invaluable food in the fight against cancer and heart disease. Chilies also aid weight loss by speeding up the metabolism.

Red stimulates the nervous system, increasing the appetite and heightening the sense of taste and smell.

If You Like Red: The key words associated with red are "achieving,"

"intense," "impulsive," "competitive," "daring," "aggressive," and "passionate."

Those who like red tend to be exciting, animated, optimistic, emotional, and

extrovert. The red person has an amazing zest for life. Their motivating force is

desire, which is manifest in a hunger for fullness, experience, and living. Their

restless pursuit of new things to turn them on can make them fickle. They often

find it hard to be objective, and they can be opinionated. Patience is not one of

their virtues. If you love red, expand your beauty repertoire from the obvious lips

and nails—a red stain on your cheeks or a touch of deep scarlet on your eyelids.

If You Dislike Red: Some people find looking at red increases

agitation and makes them feel uneasy. People who are irritable, ill, exhausted,

or bothered by problems and anxieties often reject red and turn to calmer colors

for rest and relaxation. Typically, these people are very self-protective and not as

sociable or gregarious as those who are passionate about red.

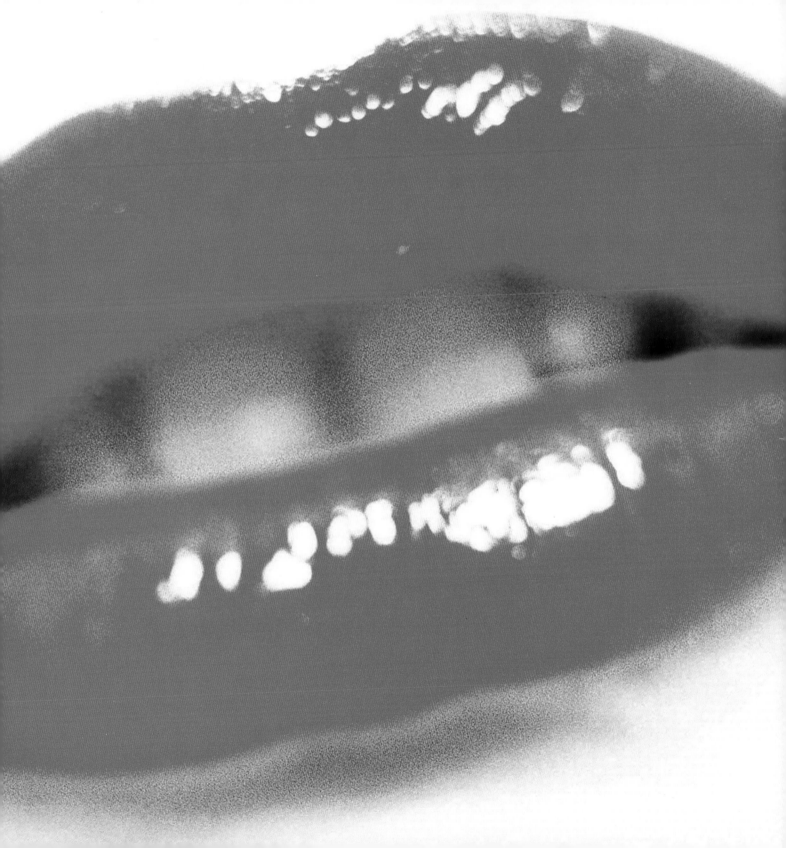

ColorSense

SCARLET, CRIMSON, BURGUNDY, ROSE: THERE ARE SO MANY KINDS OF RED THAT SELECTING THE RIGHT SHADE CAN BE ONE OF THE MOST DIFFICULT MAKEUP DECISIONS A WOMAN CAN MAKE. NOT ONLY IS THERE A PLETHORA OF SHADES FROM WHICH TO CHOOSE, BUT TEXTURES VARY SO MUCH TOO, FROM OPAQUE CONCENTRATED COLORS TO CLEAR TINTS AND SHIMMERY REDS WITH GOLD OR PINK FLECKS. SOME OF THESE CAN MAKE YOU LOOK SALLOW AND SICK, WHEREAS OTHERS MAY GIVE YOU THE VISAGE OF A VAMPIRE. SO WHETHER YOU'RE BUYING LIP, CHEEK, OR NAIL COLOR, HERE'S THE LOWDOWN ON HOW TO GET THE RIGHT ONE FOR YOU.

BLUE-REDS In plums, soft berries, and wines, these shades have a violet or purple tinge to them and are cool tones, which tend to suit people with very fair or very dark colorings.

PINK-REDS A variety of rose and fuchsia make up these pink-based reds. As cool shades they look particularly good on fair skin with a pink undertone, but tend to be too pale for black skin.

BROWN-REDS Dark berries and rich chocolatey shades make up these reds, with their deep brown hues. As warm, strong tones, they work best on olive or Asian skins.

ORANGE-REDS With hints of yellow, these vibrant reds have an inherent warmth, which means that they flatter Asian and dark skins best; the colors can drain and wash out fair skin tones.

Rubies of large size are so rare that they fetch prices superior to those of diamonds of the same weight.

inspirations

Red says "Look at me," so if you want to get noticed, wear red, especially on your lips—everyone will pay attention to what you say.

Lethargic or uninspired? Then you need to incorporate red into your fashion or makeup statements—the color stimulates activity and creativity, so it will get you going.

Red is the color of love and passion, so wearing red lipstick on a date will send out a message from Cupid. Red lips and nails, reminiscent of screen sirens and starlets, make an unbeatable combination for sex appeal.

A powerful tool, red can sometimes be too much of a good thing and seem threatening, which is why it is not a good color to wear to meetings. To tone down the effect but keep the rosiness, choose translucent reds, pinky reds, or wines instead of opaque blue-reds.

Red makes you feel empowered and confident. A matte red lipstick will give you courage and self-assurance, even when you're feeling below par.

INNER BEAUTY

We all know that beauty lies within, but this saying is more relevant than you might think. A healthy body and positive outlook do more than just put your best face forward. When you feel good inside, you really do glow on the outside, and you are more able to deal with any stresses or problems that come your way with charm and grace. In our daily lives it is not always so easy to feel beautiful inside and out, but a healthy, or healthier, lifestyle reaps many benefits. Getting enough sleep and exercise, along with a nutritious diet, will enable you to roll with the punches and will keep you on your toes. Neglect these essentials and you may lack energy and even the motivation to take care of your appearance. Remember that feeling good can make you look good.

Confidence tricks

- Focus on your best attributes—your sparkling personality, your luscious lips, your shapely ankles.
- Avoid negative thinking. Don't listen to the little voice that tells you you aren't good enough, pretty enough, thin enough. Turn the negatives to positives and tell yourself what *is* special about you.
- Get outside yourself and help someone else. Bringing your attention to others instead of yourself will keep you balanced and feeling good.
- Learn to accept your body, look after it, and delight in your individuality. Love of yourself will follow.
- Name five things you are grateful for, and really think about how they bring meaning into your life.
- Try something you've never done before—sit in on an art history lecture, go rock climbing, or travel abroad. Challenging yourself with do-able tasks (without overreaching) will bring newfound confidence.
- Take a makeup lesson. You will learn about your skin type and how to care for it, and you will pick up new information on products and techniques, which in turn will give you greater confidence in your appearance.
- Book a manicure, massage, or other relaxing beauty treatment. If you can't feel positive and full of vitality at the moment, at least you can feel pampered and relaxed.

Nutrition

Eating a balanced diet makes your body function better, your skin glow, your eyes sparkle, and it keeps your energy and concentration levels high. Skipping meals, consuming too much junk food, alcohol, or fats, or going on a diet that restricts carbohydrates or protein will only deplete your body's resources and weaken your immune system. Deprivation is not a sensible method from a physical or mental point of view. You need to eat throughout the day to keep your energy levels steady and maintain bodily functions; however, this does not mean you need to eat a lot. Moderate intake of all-natural foods will keep your body performing at an optimal level. Consider taking a juice-only day once a month. This will help eliminate toxins from your system, give your body a break from any over-indulgences, and promote bright, healthy-looking skin and nails.

Sleep

Although everyone's sleep needs vary, the important requirement is getting consistently good sleep, which means going to bed and getting up at roughly the same time every night. An adequate amount of sleep will keep you refreshed throughout the day and make you more productive, alert, and creative. Insufficient sleep results in a hollow-eyed, dark-circle look and drab-looking skin. Sleep can be a real beautifier. Scientists believe that the skin cells regenerate as we sleep, and in light of this information many anti-aging skin creams have been devised to take advantage of this nighttime opportunity.

If you have difficulty sleeping or wake during the night, try avoiding caffeine and alcohol and rescheduling your day so you are not working or exercising in the evening. Try aromatherapy, meditation, breathing techniques, or homeopathic remedies to promote an inner calm.

Exercise

Getting regular, moderate exercise increases physical strength and stamina, promotes a feeling of well-being, relieves tension, and provides an outlet for stress. However, irregular bursts of high-energy, punishing workouts do little but leave you prone to injury and exhaustion. Make exercise a daily part of your life, even if only for 15 minutes. Try to find time to enjoy it with friends, family, or as part of a team—not only will you get a wonderful glow from all the exertion but you will also widen your social circle and reconnect with people, the best feel-good factor of all.

"I save darker reds for night. Red lipstick creates an atmosphere on its own."

MAYA LEVY

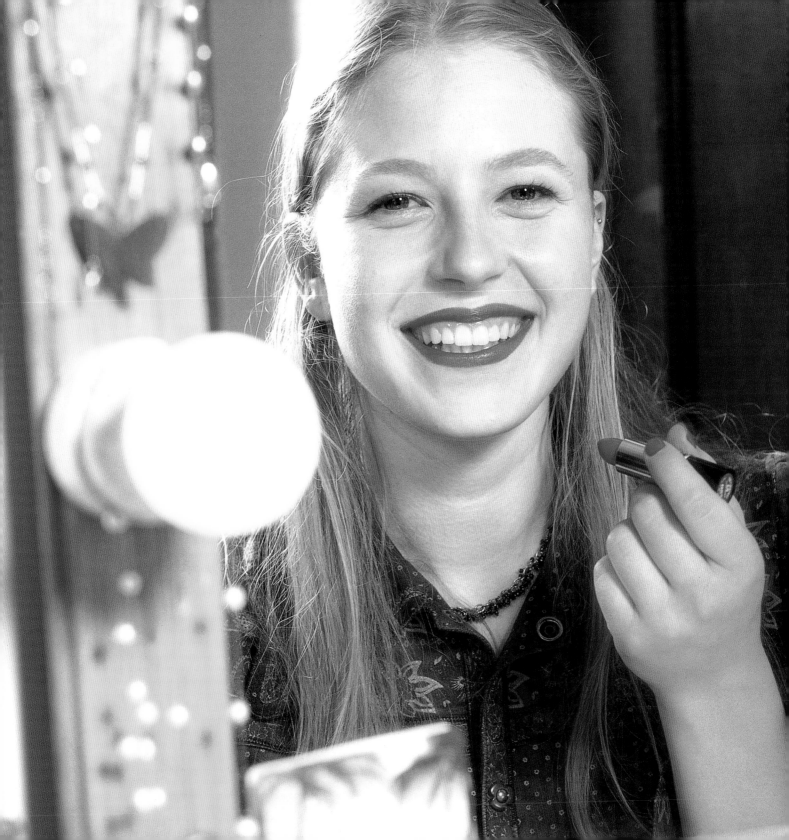

AT 21-YEARS-OLD, museum archivist and recent college graduate Maya Levy has a personality that is as effortlessly relaxed as her laid-back good looks. She tucks a piece of her blonde hair behind one ear and sinks into an overstuffed chair while listening to her father wax nostalgic about the expansive loft where they live, along with Maya's mother and younger brother. Maya's parents moved into the loft, in the heart of New York's SoHo, in 1977, and her father speaks of times when even cabdrivers had no idea how to find West Broadway. Mr. Levy laments the shoe boutiques, heavy traffic on weekends, and "Wall Street types" that have invaded their building, but despite the changes the home has an amazing energy.

One of Maya's favorite things about her looks is that they're innocent and angelic; **"So its even more fun when I'm not."**

Cluttered with black-and-white family portraits and books, the loft has the comfortable, intellectual, bohemian feel of Maya herself: easy but sharp. Maya has her own memories of growing up in the house, in which the main bathroom is the size of most Manhattan studio apartments. There is a huge lighted mirror, a gorgeous antique vanity, and a red tub made for relaxing. Once, as a little girl, Maya was given, by her mother, two brand-new lipsticks to play with, and she squashed them together. "I couldn't resist," she laughs and looks sideways. It seems she's good at charming people. In fact, she says one of her favorite things about her looks is that they're innocent and angelic; "So it's even more fun when I'm not."

Maya learned about makeup and skincare from her mother, who stressed the importance of not smoking and staying out of the sun. She recalls watching her mom getting ready for nights out. "It would take forever—I couldn't imagine what she was doing in there." Now she enjoys pampering herself in the very same bathroom, and it's where she applies her own daily routine of makeup. Maya listens to Bob Dylan and Led Zeppelin as she primps for a night out, smoothing on subtle red lipstick that suits her blue eyes. "That's when I feel prettiest, at about 8 p.m. on a Saturday night during the summer—everyone is walking around on their way to something. The energy in the air—it's so sexy, so New York."

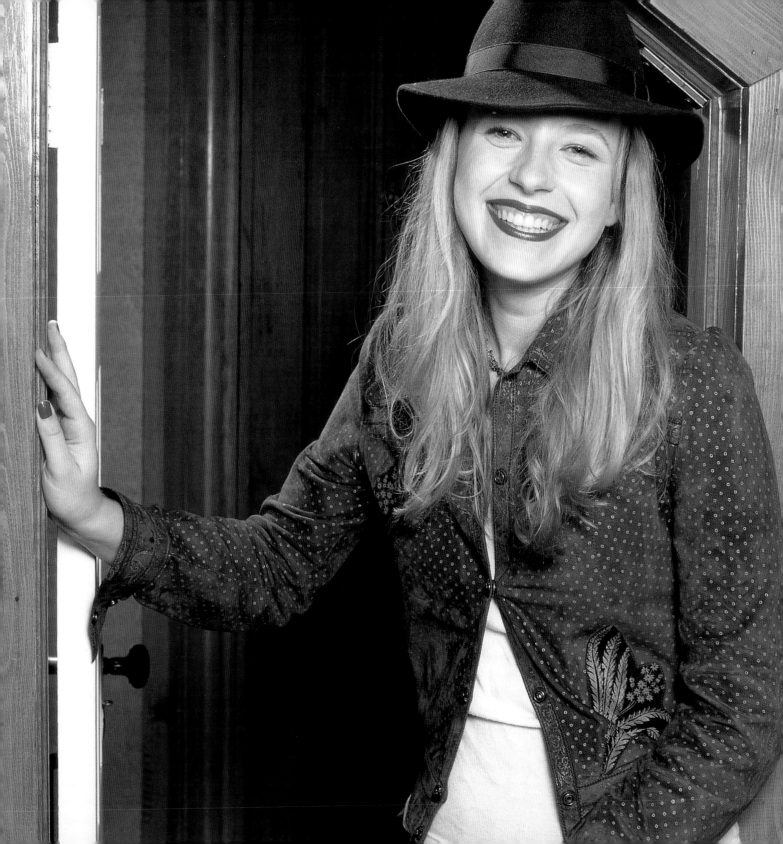

Red for Day:

For a sunny day in Manhattan, Maya's naturally dewy complexion requires just a bit of concealer and a cream blush on the apples of her cheeks. She blends and applies red lipstick with her fingers to give the appearance of a stain and just the right color. By dabbing it on with the ring finger, she can control the amount of color while achieving a natural look. She applies a thin coat of mascara, and she's ready to go.

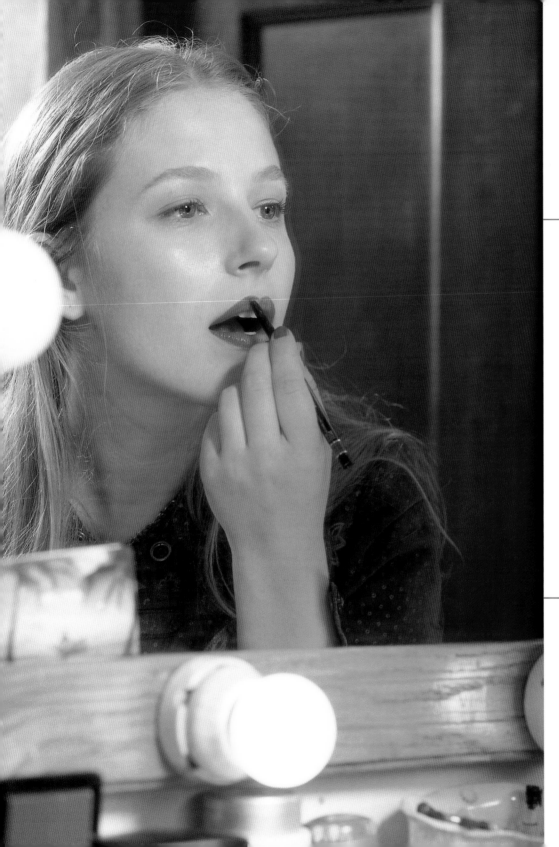

Red at Night:

As for her daytime look, Maya uses a small amount of concealer, plus a liquid foundation, topped off by a cream blush. Although red lips are right for any time, they can be made to look the deepest and sexiest at night. Maya starts with a nude liner in a natural shade, then she fills in with a deep but bright red, suitable for her light hair and eyes. For her eyes, Maya adds a little extra drama with a smoky gray shadow and slightly smudged liner on the top lid. Two coats of black mascara finish off the look.

Get This Look: **THE RED POUT**

Someone once said that if you want to be heard, wear red lipstick. But red doesn't have to be a strong statement—unless you want it to be. A hint of a stain or a gloss with a touch of shine can be just as effective. What better frame for a million-dollar smile than perfectly polished lips? From lip balm to syrupy gloss to a matte neutral shade or the ultimate classic red, you can change lipstick to match your mood. Other aspects of makeup, like foundation or mascara, can fall into a routine, but lipstick can go from pale nudes for a well-groomed look during the day to sultry scarlet after hours. And for an all-out girly look, match your nails to your lips. The important thing to remember is to do what feels comfortable and be true to your own inimitable style. There are as many ways to apply color to your lips as there are shades, so experiment to find the method that works best for you.

STEP BY STEP: PERFECT LIPS

This technique will give you long-lasting, sultry lips every time. Choose a liner that is the same color as your lips or a shade lighter than your lipstick. That way, you won't be left with a dark outline if your lip color fades.

1 Before you begin, cover your lips with a thin layer of foundation or powder to provide a good base for the color. Make this an automatic step when making up your face.

2 Starting at the center of your upper lip, draw a line to each outer corner, following the edge of your natural lip line. Repeat to draw a line on the bottom lip.

3 Apply lip color—whether from a tube, a brush, a wand, or your finger—from the center of the top or bottom lips, and glide the color to the corners.

4 Blot with a tissue, reapply the color, and blot again. Add a dab of gloss or shimmer on the center top and bottom.

TIPS

• Chill your lip pencil in the refrigerator or freezer for a few minutes before sharpening; it makes the task much easier.

• Moisturize with lip balm before the temperature drops to avoid chapping.

• If you're applying red lip gloss from a jar with your finger, dab a bit on the apples of your cheeks for a flushed complexion.

• Never draw a line outside your natural lip line—it won't make lips look fuller.

LIPSTICK GLOSSARY

Matte Lipstick: Mattes tend to stay put longer than classic cream formulas, and the color usually appears rich, with great texture but little shine. The downside of matte is that it can harden and crack if lips are dry—apply lip balm liberally at night if this is the case.

Cream Lipstick: Creams offer hydration and have a looser, more liquid feel than matte types. They glide on easy and often have more luster.

Lip Gloss: Glosses vary in consistency from heavier syrups to lighter, more airy substances. They can be applied with a wand (if they come in a tube) or with a lip brush or the finger.

Lip Stain: The color of a lip stain looks much darker in the container. It has a thin, almost liquid consistency and is transparent with a touch of lasting color.

Lip Brush: Many women prefer to apply color with a lip brush. As with all brushes, natural hair is best, and a retractable applicator comes in handy.

Lip Liner: In a pencil form, liner is an essential for creating the perfect pout.

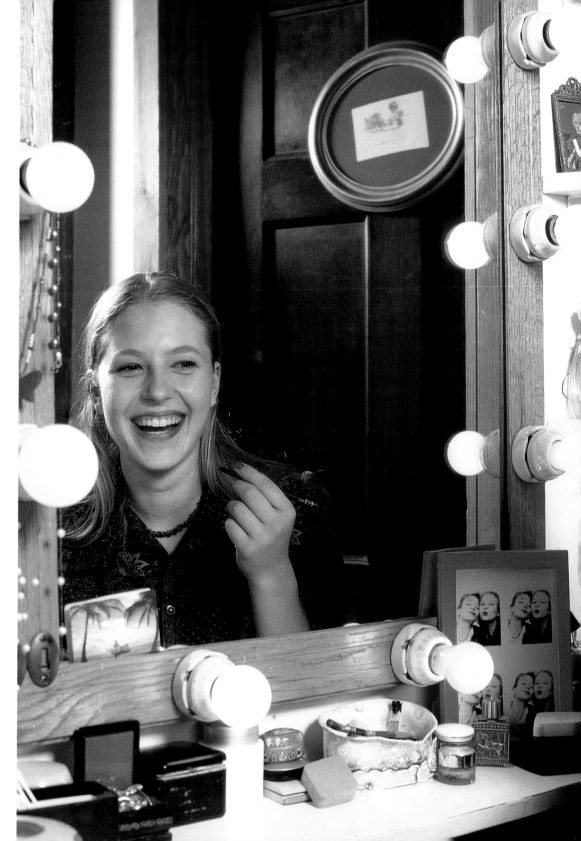

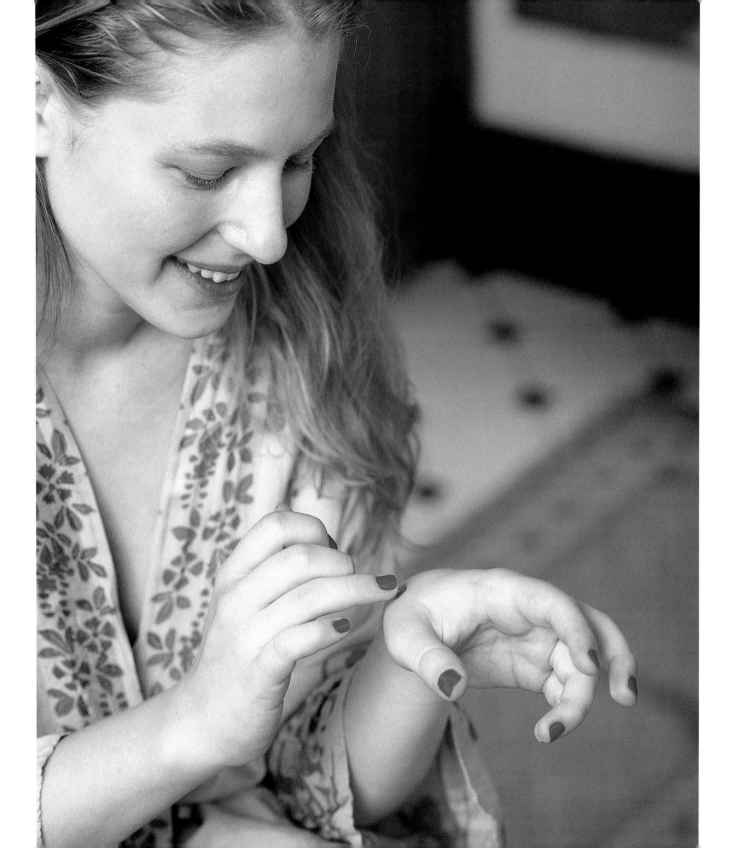

Get This Look: RED NAILS

Few looks are more sophisticated than a perfect ruby red manicure. Whether a dark rouge burgundy, a tomato red, or any of the countless reds available, the color ups the glamour quotient of a look. However, manicures using deeper colors are slightly trickier to pull off than those using lighter shades. The darker pigments may leave a stain on the nails if you forget to apply a base coat first. Red nails can look groomed and sophisticated or vampy and sexy, but whatever image they project, they will get noticed, so make sure your manicure is flawless and chip-free. Get perfect scarlet nails with the following tips.

TIPS

- Make the nail look longer by leaving a thin strip of bare nail to each side edge.
- Never use more than two coats. If you do, it will take an eternity to dry, and when it does, it will most likely peel.
- Red nails are much less forgiving than sheer shades. Take time with the manicure so the color stays chip-free.
- Red is fabulous on the toes, but again it's messier than lighter hues. A toe separator is a must.
- Consider using a shimmery top coat for a playful accent.
- Hold freshly painted nails under cold water to harden the color more quickly.
- Never load the brush; instead use two thin coats.

STEP BY STEP: NO-FAIL NAILS

Follow this technique to go from bare to high-impact in five easy steps. To really protect your scarlet color from chipping, reapply a clear top coat every other day.

1 Remove old polish, swiping from the base of the nail to the tip. If the color is difficult to remove, hold a cotton ball, saturated in remover, over the whole nail for a few moments.

2 File nails, push back cuticles, and thoroughly cleanse the hands, especially the nails. If anything is on the nails, the polish won't adhere properly.

3 Apply a strengthening base coat. A good one will also guard against stains and fill ridges.

4 Use three strokes to apply a thin coat of color to each nail—the first down the center of the nail from base to tip and then one on each side. Let dry and repeat.

5 Apply one coat of clear, chip-resistant, high-shine top coat to seal and protect the color. Leave to dry naturally.

Reds for Everyone

"Red lipstick is easier to wear than people think," says makeup artist Molly Stern. "A red lip is a true classic, it adds a bit of drama to any situation." Stern explains that the more modern way to wear red is without lip liner. However, if wrinkles around the mouth are a problem, liner can prevent dark lipsticks from bleeding into the skin around the lips. As with any strong makeup statement, bold red lips can stand alone and should be combined with neutrals on the rest of the face. "Red lipstick exudes confidence. It can add an energetic mood even if you're not necessarily feeling it." You don't have to limit red to the lips. A dramatic red can be worn on the eyes, but not too close to the lash line; instead use it for contour to create a moody effect.

Blondes

If you are blonde, try a red gloss with a touch of blue, or wines and russets.

Brunettes

MANY KINDS OF RED WORK ON THOSE WITH BROWN HAIR, FROM CLASSIC BLUE-REDS TO YELLOW -REDS TO CLEAR, SYRUPY GLOSSES.

Asian Skin

Those with yellow skin tones should choose a red with blue in it, as opposed to an orange-red.

Redheads

Redheads should choose shades of red with brown and golden undertones.

Dark Skin

A burgundy lip on dark skin looks powerful and sophisticated.

Olive Skin

DARKER SKIN LOOKS FANTASTIC WITH DRAMATIC RED LIPS. BLACK LIQUID EYELINER CAN COMPLETE THE LOOK.

orange
naranja
cora
range
cora
corallo
narar
orail
corail

orange and coral

coral

corail

narar

corallo

ja

arancione

arand

Our Associations with Color

Energizing and reinvigorating colors, oranges and corals are daring and upfront. Just seeing these shades lifts and lightens the mood. Influential and independent people are said to be the strongest advocates of orange, perhaps because they are more secure in indulging offbeat tastes. In fact, orange is known as a favorite of the design-conscious and self-motivated. The color makes us think of the sun and warmth, the glow of embers in a fire, and autumn leaves. Orange is a color you can taste. The citrus bursts into your mouth and awakens the senses. And increasingly, vitamin C, the main vitamin associated with oranges, is being infused into skincare and anti-aging creams, proving how full of vitality orange can really be.

Vitamin C

- An effective ingredient in many skincare products, vitamin C promotes an increased production of collagen, diminishing fine lines and wrinkles and giving the skin a firmer appearance.
- Vitamin C increases the skin's ability to hold moisture, shields skin from UV light, and encourages healthy cell regeneration, which makes it effective therapy for traumatized skin and the red skin condition rosacea.
- The vitamin also plays an essential role in the immune system. It is found in every cell of our body and performs various functions: it is vital to the production of collagen; it aids in neutralizing pollutants; it is needed for antibody production; and, finally, it has natural antihistamine properties.
- Vitamin C helps reduce the severity of sinus stuffiness and runny nose.
- As our bodies do not produce the vitamin, it is imperative that we get it from other sources. The ideal way is to eat fruits and vegetables that are high in vitamin C. Do not smoke, as it depletes the body's stores of the vitamin.
- The vitamin C content in most fruit produce is higher when the fruit is slightly immature, and declines as the fruit hits peak ripeness. Some fruit and vegetable sources for vitamin C, other than oranges, include grapefruits, lemons, limes, mangoes, pineapples, and strawberries.

Orange is a color of love
and happiness
to the Chinese and Japanese,
while the orange robes of
Buddhist monks
represent humility.

If You Like Orange and Coral:

Orange and coral are a combination of red and yellow, so they take on many of the characteristics of both colors. With the physical force of red, the colors are vibrant and warm, but less intense, less passionate. Lovers of these colors work hard, but spend their leisure time seeking adventure. Very good-natured, sociable, and extroverted, they are known as the life of the party. They can be fickle and can make undependable mates—they're always looking for new worlds to conquer. If you prefer peach tones, you have all of the same traits as the orange-loving person, but you are much less assertive about it. If you love orange, indulge your color craving in a peachy blush or a coral eyeshadow.

If You Dislike Orange and Coral:

Life is not always a happy affair for those who reject orange and coral. Nothing dramatic appeals to them, and they shy away from too much showing off, loud laughter, and overzealous partying. If you are one of these types, you may be a loner but also more loyal than, and not as fickle as, an orange-lover.

"There is no blue without yellow and without orange."

VINCENT VAN GOGH

ColorSense

ORANGES AND CORALS REALLY ZING AGAINST THE SKIN, BUT DO CHOOSE HUES THAT WORK WITH YOUR SKIN TONE. DARKER SKINS CAN TAKE DEEP SATURATED CORALS ON THE CHEEKS OR LIPS, BUT PALE SKINS NEED A SHEER SHADE THAT GIVES JUST A HINT OF COLOR. CONSIDER THE DENSITY OF THE COLOR YOU ARE USING, WHETHER IT IS SHEER OR OPAQUE. TRANSLUCENT ORANGES CAN BE WORKED IN LAYERS OVER BARE SKIN TO CREATE A LUMINOUS GLOW, WHILE RICH SHADES CAN BE COMBINED WITH GOLDS FOR AN INTENSE AND VIBRANT FEEL.

Orange is a color for all seasons. A bright and shimmery coral is undeniably better in summer and spring, while a deep, gold-accented orange seems right when the temperature drops. Spring is the perfect time of the year for peach cheeks and lips. Think of cinnamon-orange for lip color in winter and zesty citruses in the hot months.

Experiment with orange eyes and cheeks, or cheeks and lips, but do not match up the whole look. A coral blush, brushed on the apples of the cheeks, combined with a wash of clear orange eyeshadow, will prettify the face.

Combine corals and orange shades with nudes and neutrals for a natural look. Wearing such strong colors requires that you tone down the overall look a little to give it some subtlety. The orange will also lift the neutrals a little.

Tan hands and feet look great with orange nail polish. It makes a fresh change from reds and pinks and works especially well on toes when worn with a pair of slinky gold stilettos. To liven it up, add a coat of pale-colored shimmer or gold glitter over deep coral polish to make your fingers and toes sparkle.

"Orange is the happiest color."

FRANK SINATRA

inspirations

Orange denotes warmth and wholesomeness, and it has broad appeal. It says you are willing to take chances, so it is a good color to wear when you are meeting new people.

Because orange is associated with vibrancy and life, use it when you need a sudden spurt of enthusiasm. Orange and coral shades are fresh and vital colors, and stimulate energy, so they work especially well when combined with active wear.

Ambers and burnt oranges are warming and wintry in feel; wear them when you want to kindle deep passions over a candelight dinner.

Evoke a tropical island paradise by wearing bright yellow-oranges in warm weather, when you need only a soft wash of color to enhance your natural attributes.

Design-conscious and stylish, orange lets others know you are discerning and one-of-a-kind. Use it as an accent paired with navy, brown, or cream.

SPECIAL OCCASION COLOR

Some social events require a little thought when it comes to cosmetic preparation. If you've been invited to a black-tie party, a corporate function, a wild late-night rave, or a family picnic, you will automatically consider the dress code, but equally you need to consider the makeup code. Give some attention to what is appropriate for the occasion, even running a dress rehearsal before a big event. Harder, slicker makeup works well with a pantsuit, but slinky clothes need a face with a feminine treatment, and you couldn't possibly attend the neighbor's lunchtime barbecue looking anything but fresh-faced.

Sophisticated Glamour

The classic matching lips-and-nails look has never really died out; it's a look of a certain era and a flashback to the old-style glamour of Hollywood, but it is also immensely suitable for those with strong looks, such as the raven-haired and fair-skinned. To achieve this look, use a primer under foundation to even out imperfections. Keep cheeks bare of color to project the image of flawless skin, and then create depth of color on lips with an intense, full-on lipstick. Eyeshadow should be minimal, but plenty of mascara and liner dotted close to the lashes will give a seductive fluttering effect that fringes the eyes.

Glitter and Gloss

The trick to the disco diva look is to add accents with glitter, gloss, or highlighter. Begin by creating a doll-like look using a frosted shadow in a pale color to open up the eye and a pinky-peachy cheek. For pouty lips, use a lip primer then a pearlescent color, smudged on. Line a smoky shadow along the lashes. Now apply a clear shimmery gloss over the eye. Accent the outer eye, or alternatively the browbone, with glitter, dabbing a little glitter into the center of the lips, too.

Smoldering and Mysterious

Kohl-rimmed eyes and nude lips create a seductive, mysterious look. Because darker colors are now light-reflecting and less dense than they once were, you can layer metallic grays and charcoals, taking a sheer black from the outer corner of the eye into the crease. For a saturated color, finish by lining the eyes with a black liquid eyeliner and then use a wet powder eyeshadow and brush to line the eyes again, blending the color into the sheer black shadow at the outer corners of each eye. Alternatively, use a black eye pencil along the inner rim of the eyes. If you find this look too intense, limit dark shadow to the outer half of the eyelid, and use a pale shade for the inner half. Alternatively, layer on similar shades of the same color, such as lilacs with deep purples or rich browns with plums.

Polished and Natural

Layering sheer tints and lightweight creamy colors onto a mattifying foundation will give a fresh, natural look that will carry you from the home or office to a casual social event. Keep brows groomed and brushed into place, makeup colors in the neutral palette, and lips and cheeks in a hint of peach or terracotta. Keep shimmer and gloss to a minimum. A useful technique is to keep the eyes and mouth light and add a brighter flush of color on the cheeks.

Romantic

A summery feminine look can be achieved by layering luminescent sheer colors and coordinating lips and cheeks. Choose pinks or peaches according to your skin tone. Define the brows with a powder. Do not line the lips, but apply a lipstick and then blot off to leave an "undone," just-kissed feel, or alternatively rub in a lip stain. Finish with a slick of lip gloss. Add a little shimmery highlighter to the tops of cheeks, browbone, temples, and inner eye, and along the collarbone.

Quick Party Tricks

- **Refresh red, tired eyes with eyedrops.**
- **Use a shimmer stick on cheekbones to brighten up the complexion.**
- **Always wear foundation to even out tone, even if it is only along the center of the face.**
- **Don't overdo under-eye concealer, as it can look caked and make you appear tired and lined.**
- **Smooth a golden cream shadow from lash line to brow, and then apply a rich metallic hue in a thick line along the top eyelashes, flicking it out at the corners.**
- **Update red lips by going for a deep coral.**
- **Use deeper, richer shades of eyeshadow and blush rather than just more of your usual colors.**
- **Apply a glitter mascara or line the eyes with a glitter crayon for an instant festive feel.**
- **Decorate nails with a quick-dry nail color, top old polish with a sparkle coat, or better yet apply a coat of a clear glitter (the clear base hides mistakes well).**
- **Finish your face with a pearlescent colored face powder or bronzer.**
- **Don't be tempted to mix gold and silver or to add too much glitter (to lips, eyes, *and* cheeks).**
- **Tip a bright or dark nail color in gold, or use silver along the top edge of a white or cream nail for a new spin on the French manicure (see page 190).**

"I love when my cheeks turn a peachy shade ... I just feel better."

MILLIE KIM

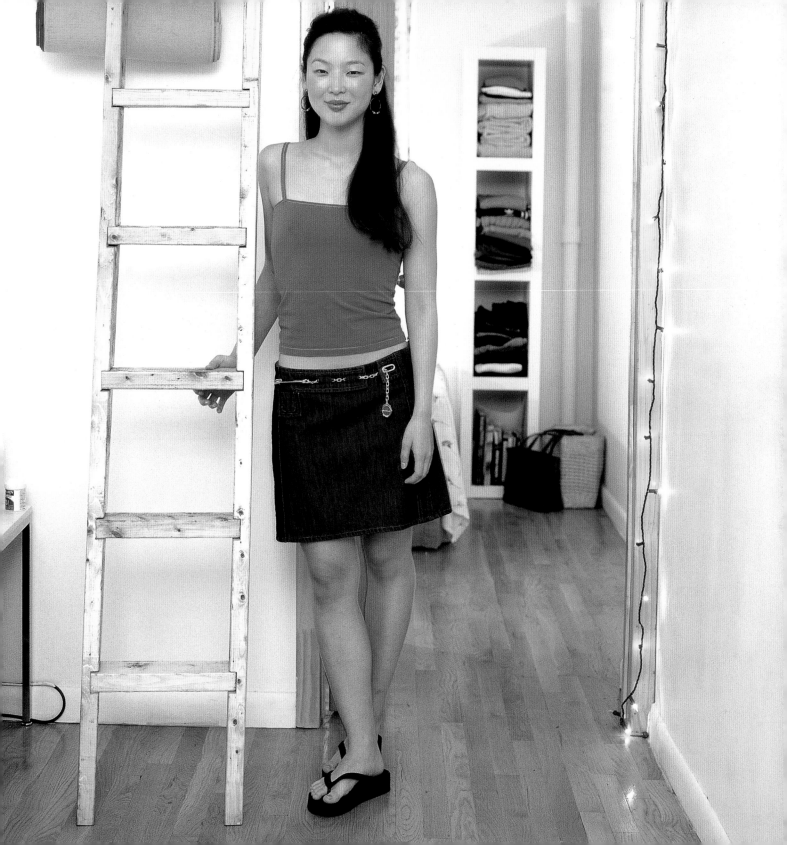

22-YEAR-OLD Millie Kim has the supple, dewy skin that makes those around her sigh with envy. It's not just the full lips and long, thick black hair with just the right amount of wave—"She has absolutely no visible pores," points out makeup artist Liza Zaretsky, "Millie's skin literally glows." Millie, a music aficionado, says music is a big part of her getting-ready routine. "My sister and I play upbeat music to wake ourselves up." Funk and hip-hop blare throughout their tiny loft apartment. "The neighbors usually start banging so we have to turn it down," Millie admits sheepishly. Millie is the youngest of three

> **"We used to sit around my mother while she was getting ready to go out. We'd watch her apply lipstick and spray perfume and brush her hair. We watched her every move."**

sisters, so she grew up in a house with intense feminine energy. "We used to sit around my mother while she was getting ready to go out. We'd watch her apply lipstick and spray perfume and brush her hair. We watched her every move." Millie has created a similarly feminine feeling in the apartment she now lives in with her sister. Fairy lights line the walls and the apartment is strewn with bags and shoes and makeup—and of course CDs.

It was in high school that she wore the most makeup. "Really dark eye makeup and maroon lips." She laughs at the memory. "I was experimenting. It was before I learned that less is more." The lighter colors she uses now really suit her skin tone, and Millie loves her skin in the summer. "I love when my cheeks turn a peachy shade of pink and you just feel better. Good health is what makes me feel the best."

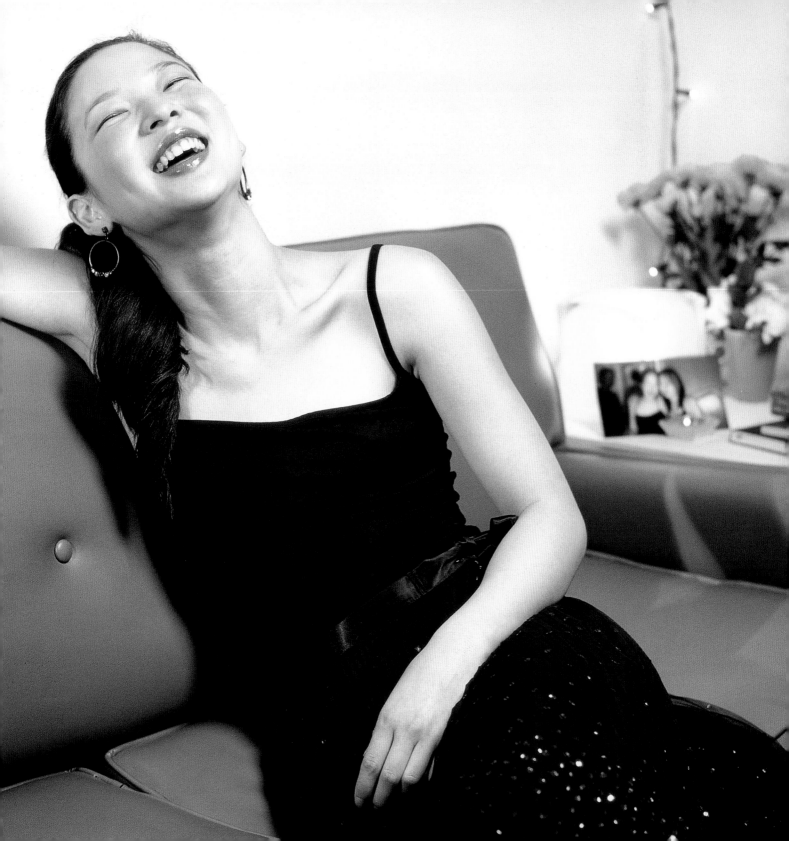

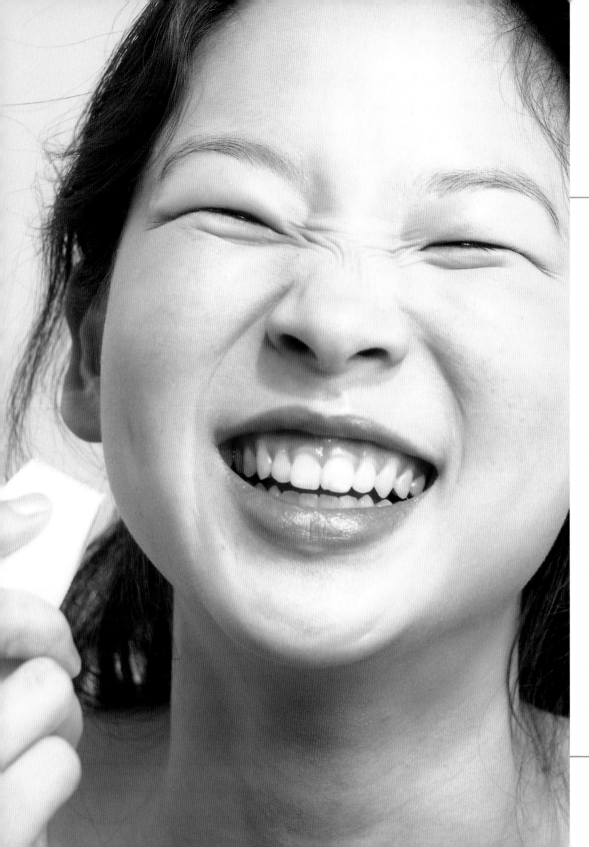

Orange and Coral for Day:

Millie has the amazing dewy skin of youth. For the daytime, she applies a loose powder over a sheer liquid concealer, and then adds a pale peach cream blush for a healthy, natural look. Millie adds a touch of highlighter to the apples of her cheeks and to the browbone for a rosy shimmer. She layers an apricot-colored lip gloss with mocha tones over a nude lip liner. A wet/dry eyeliner in brown with a nude cream eyeshadow is blended on Millie's eyelids. She curls her eyelashes and applies extended-wear mascara in black/brown, which accentuates her eyes without overpowering the rest of her face, which is made up in a predominantly soft palette.

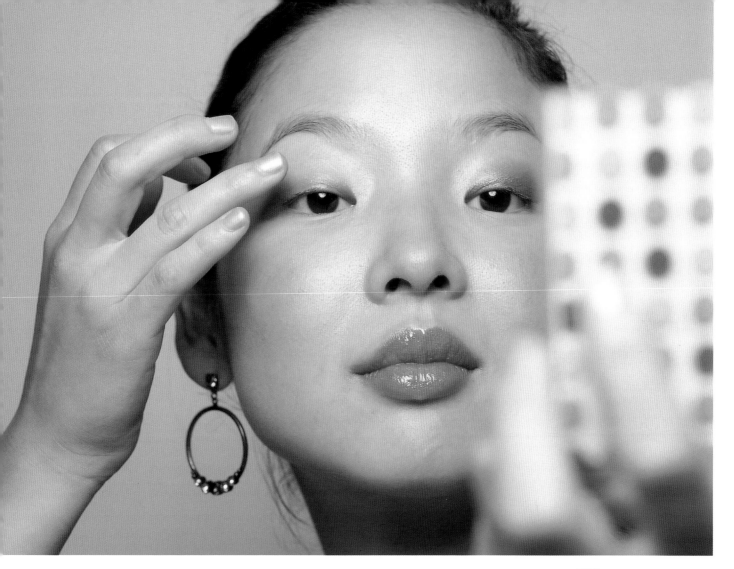

Orange and Coral at Night:

For nighttime, Millie intensifies her eyeshadow by adding tawny shades of coral in the crease of her eye and a bronze liquid eyeliner on the rim of her eyelid. Millie wears a lip gloss, specially formulated for extended wear, in a bright coral shade and a cream blush on the apples of her cheeks. Her nails are an iridescent peach, and her eyelashes have two coats of black mascara for a little more drama. An illuminated highlighter gives a finishing touch of shimmer on her browbone and under her eyes.

Get This Look: SWEET CHEEKS

Though you rarely hear people discuss cheeks and cheekbones as a focal feature of the face, they are actually one of the most integral parts of the overall look. The accepted technique used to be to apply blush underneath the cheekbones, but now the apples of the cheeks are where the focus of color should be. According to makeup artist Liza Zaretsky, anyone can easily find the apples of the cheeks by making a wide smile in the mirror. Applying blush here adds youth and vitality, and makes you look naturally flushed.

STEP BY STEP: POWDER BLUSH

The traditional form of blush is a powder, which provides a polished look and is good for oilier skins. It can be used for contouring the face, in which case it should be applied underneath the cheekbones in a cool brown tone to mimic a shadow.

1 Dab the top edges of a sable-haired blush brush in the powder color. Shake off any excess by tapping the brush.

2 Apply the blush color by stroking from the apples of the cheeks upward and outward.

3 Add more if necessary, but avoid extending the color beyond the outer corner of your eye.

CHEEK COLOR GLOSSARY:

Powder Blush: Powder is applied with a brush and can be used on the apples of the cheeks, as well as under the cheekbones for contouring and highlighting.

Cream Blush: Smoother to the touch and easy to blend with the fingertips, cream blush should be applied over moisturizer.

Blush Brush: Makeup brushes come in dozens of shapes and sizes. Brushes specifically meant for blusher are usually medium in size (somewhere between loose powder and eye-shadow brushes). Though natural hair bristles are expensive, they last forever and should be considered an investment purchase.

Cheek Stain: A sheer liquid, cheek stains come in containers that typically resemble nail enamel bottles. Stains set in very quickly (hence the name), so they need to be blended and shaped on the face immediately after touching your skin. They usually wear all day.

Shimmer: Shimmer, in stick, cream, or liquid form, looks loveliest along the top of cheekbones.

STEP BY STEP: CREAM BLUSH

While cream blush has been around for a while, recent advances offer formulas with better blendability and color choice. Cream blush provides a more natural, fresh, dewy look. It can come in either a tube or a jar and can be applied with either the fingers or a makeup sponge.

1 Dip a sponge makeup applicator or your finger into the center of a jar of cream blush, or alternatively squeeze the color onto the sponge or a finger.

2 Smile to find the apples of your cheeks, and apply the color directly to them in a circular motion. Cream blush lightens within a few minutes of application so don't be shocked if the color is darker than you expected. The motion of the sponge on your skin can also add redness.

3 Once the blush is in place, use your fingers or a clean part of the sponge to blend and even out the color.

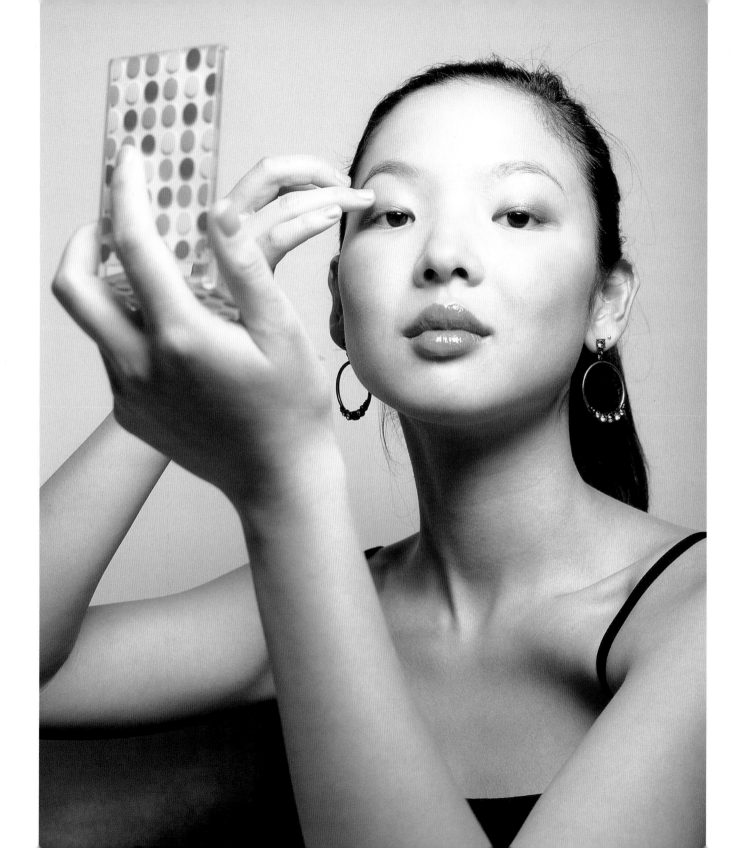

Get This Look: DEWY EYE COLOR

A cream shadow formula is a better option for translucent washes of color on the eyes than traditional shadow, because it provides a dewy, moist texture as opposed to the chalky feel of powder. Glosses and tints are also great for getting a fresh look because they are highly reflective, glide on easily, have a light texture, and can be blended with other colors much like artist's paints. Experiment with different shades of oranges and corals to decide which one is right for you (see also pages 72–73 to find out which one is best for your skin tone).

STEP BY STEP: CORAL EYES

Though coral isn't always immediately associated with eye color, it actually works quite well on this area of the face. It may take a bit of getting used to, but once the compliments start rolling in, it's sure to become a staple in your eyeshadow rotation. Go for a subtle approach, as you will want to extend the color onto the lips and cheeks, too.

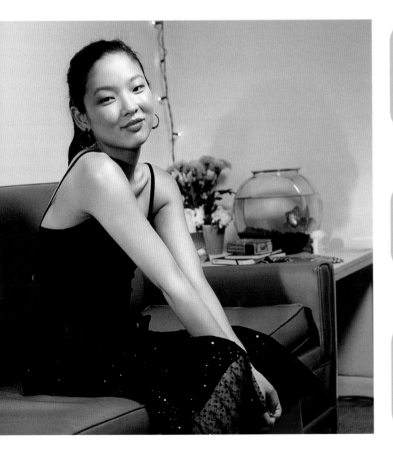

1 Start by blending a little of your foundation over the eye area to provide an even base for the color. If you are using an eyeliner, apply it now before your eye color, taking a touch of charcoal or brown pencil, or a liquid liner, along the top edge of the eyes only.

2 Dab a tiny amount of the coral eye color onto your finger and slick it onto the eyelids and into the crease. Avoid going all the way to the browbone, which might be too much. Repeat if desired to build up the color at the outer eye.

3 Dab a little gold highlighter into the center of the lid and onto the browbone, if you like. Alternatively, finish with a clear eye gloss over the color for an extra-sultry look. Now add a couple of coats of mascara to the upper lashes only to open up the eyes, sweeping from the roots to the tips.

Oranges and Corals for Everyone

"Oranges and corals can be among the more difficult colors to wear," says makeup artist Liza Zaretsky. "But if you find the right shade and apply it well, they can also be among the most flattering." While orange is a natural choice for those with strong coloring, softer tones can also lift pale looks.

Blondes

Fair-skinned blondes with pink tones can enhance their coloring by incorporating coral makeup into their routine, especially in summer. Warmer blondes usually look better in peach and golden oranges.

Brunettes

THE DARKER YOUR COLORING, THE MORE GOLD TONES YOUR ORANGES AND CORALS SHOULD HAVE. USE AN IRIDESCENT CORAL NAIL ENAMEL OR LIP GLOSS.

Dark Skin

Saturated oranges enrich dark skins and draw attention to facial features. Some dark skins can tend to look ashy, but an orange tonal foundation can correct this, and even concealer with orange tones will work well.

Olive Skin

OLIVE-SKINNED WOMEN LOOK GREAT IN BRIGHT CORALS MIXED WITH ORANGE-ACCENTED METALLICS, SUCH AS BRONZE OR COPPER.

Fair Skin

Mandarin orange brings a flush of color to ivory skin with peach undertones, while salmony oranges and pale corals suit porcelain skin.

Redheads

A soft peach gloss with a sheer wash of coral on the cheeks is a perfect look for redheads and those with pale, freckly complexions.

gelb
amarillo
giallo
oro
gul
gull
gold
gelb

guld

yellow

and gold

Our Associations with Color

Yellow recalls the sun, that great disk of fire high in the sky, and the terrible heat of the life-giver. Yellow then, makes a forceful statement, suggesting energy and power. It represents the generation of life and the continuity of a new day rising. Gold's associations are primeval, too, and it has long been regarded as our most precious metal; turning base metal into gold was the goal of every alchemist. The color conjures up images of Pre-Columbian artifacts and Egyptian sculptures, along with the worship of the sun and desire for the attainment of the heavens and the gods. These colors are mystical, powerful, and ancient.

The Sun

• Sunlight provides us with our main source of vitamin D, which promotes calcium absorption, maintains a healthy nervous system, and boosts the immune system. Just ten minutes of exposure each day will supply us with all the vitamin D we need.

• The sun can actually alter moods chemically and even prevent depression. The onset of spring gives thousands of people relief from "Seasonal Affective Disorder" or SAD. This condition is caused by the suppression of the powerful neurotransmitter called serotonin in the brain and is experienced by many that are deprived of sunlight during the dreary winter months.

• Sunlight stimulates the pineal gland—a tiny pea-sized organ found in the base of the brain. The pineal gland produces certain types of chemicals called "tryptamines." One type of tryptamine, melatonin, keeps our body clock aware of night and day and the changing seasons. This is why some doctors suggest melatonin supplements to beat jet lag.

• It's important to keep in mind that the sun is extremely dangerous. Each time skin becomes tanned or burned, the DNA in skin cells is affected. Some cells simply die while others are able to repair themselves by getting rid of the damaged DNA. Applying a sunscreen every day, whatever the weather or time of year, is good basic skincare advice. You do not need to be on the beach to risk overexposure to the harmful rays of the sun. Ultraviolet rays are extremely strong in the winter, especially if they are reflecting off snow, and even overcast days in the city carry risk.

• If you must go out in the sun, always wear a sunscreen of at least SPF15, and make sure it screens out both UVB (the burning rays) and UVA (the aging rays). The most dangerous times of the day are between 10 a.m. and 3 p.m.

In stained glass, **yellow** represents **the sun** and the treasure of heaven.

If You Like Yellow and Gold: Lovers of yellow

can be highly imaginative, idealistic, creative, and artistic. They are often concerned with the spiritual side of life. They tend to be perfectionists, but love challenges. They make reliable friends and have sunny dispositions. Gold-lovers like to be showered with attention and are often egotistical, not liking to be second best. They can be generous, but may be shy, appearing a little aloof. They may be impatient with others' ideas if they seem less thought-out than their own. They tend to spend more time talking than doing. If you like yellows and golds, use them in unexpected places like nails or cheeks. Gold shimmer on the cheekbones, eyes, or lips will give you a glamorous look and draw attention to your features.

If You Dislike Yellow and Gold: People

who are not fans of these colors are usually realists—practical and probably critical of others who are not. They usually thrive on deadlines and detail, and need a signature on the dotted line. Not much for experimentation, they prefer the tried and tested method of doing things.

ColorSense

YELLOWS AND GOLDS REFLECT LIGHT, WHICH IS WHY THEY ARE SO OFTEN USED TO HIGHLIGHT SKIN AND HAIR COLOR. MANY MAKEUP PRODUCTS— AS IN EYESHADOW, LIPSTICK, BLUSH, AND NAIL ENAMELS—AND SKINCARE FORMULAS HAVE GOLD FLECKS OR PARTICLES ADDED TO THEM TO BRING EITHER A SHEEN OR AN OUTRIGHT GLITTER TO THE FINISHED TEXTURE. USE YELLOW-BASED POWDERS, SHADOWS, AND BRONZERS ON THE FACE OR BODY TO ADD WARMTH TO THE SKIN TONE. STREAK NATURAL COLORS—SUCH AS BEIGE, NUDE, TAUPE, AND COFFEE—WITH GOLD DUST TO ENRICH THE SHADE.

Use shades of gold to accent areas of the face and neck. Try (though not all at once) a shimmer in the center of the lips, the browbone, the cheekbone—or even the collarbone.

Pale lemon or canary yellow, while not traditionally thought of as colors for cosmetics, can actually look quite lovely on the eyes. More intense than cream, these shades still share some of the same qualities; namely, they open up the eyes and make them appear fresher and more youthful.

A little cream or liquid gold shimmer mixed in with your regular foundation is the perfect touch of glamour for a night out. Also try mixing yellow or gold dust into shadows, lipsticks, and cheek colors to give them a new lease on life. Another idea is to mix the dust into body lotion or face moisturizer to slather skin with a sun-kissed glow.

For a party look, sprinkle gold in the hair or over the décolletage. Look at the size of the glitter particles, though—large ones are attention-grabbing, while tiny ones add a subtle highlight.

Yellow **enhances** concentration and is considered an **optimistic** color.

inspirations

Yellow isn't just for sunny summer. Because yellow is the ultimate statement of cheer, it is the perfect antidote for a drab winter day. Pick warm, buttery shades, or else try yellows that remind you of harvest sunsets and the burnt yellow leaves of autumn.

Nothing says "holiday" like gold. Dust a scented metallic shimmer on the shoulders and arms or spice up neutral lips and eyes by adding clear gold gloss on top.

Gold represents status and riches the world over. Think St. Tropez in summer and dab some gold glitter onto your fingers or toes. Or go for the St. Moritz ski-bunny look in winter and add a little gold shimmer to your face.

Optimistic, playful, and attention-getting, yellow can provide you with a positive outlook even when you're lacking one. A cool yellow eyeshadow with blue undertones will look happy and fun.

STAYING POWER

Because we don't always get the chance to reapply our makeup during the day, we really want it to last as long as possible. Fortunately there are countless products and application techniques to help make this aim a reality. Long-lasting, nontransferable, waterproof makeup will stick by you through sad movies, weddings, sports activities, and intimate encounters, but for some hands-on help, follow the tips below.

> **"**There are painters who transform the sun into a **yellow** spot, but there are others who… transform a yellow spot into the **sun."**
>
> **PABLO PICASSO**

Make It Last

- When applying foundation, pat it into the eye socket and over the lips. This will help the shadow and lip color adhere.
- Use a primer or mattifier before foundation and a dusting of powder after makeup is complete.
- Layering will help keep color from sliding. Build up thin layers of concealer and foundation, working only in the areas where it is really needed. For eyes, too, build up thin layers of color and blend, blend, blend.
- For blush, apply once, dust with powder, and then apply a second coat.
- Using powder eyeliner on top of a liquid eyeliner will help to set the color.
- Curling your lashes before applying mascara will help color hold on rather than drift onto the cheeks or fleck off.
- Apply one coat of mascara over the top of the upper lashes and then two coats from below.
- To set brows, brush into place and sweep with a clear mascara.
- Line lips, then fill in the entire lip with the liner. Add lipstick, blot, repeat, and finish with a gloss or sealant.
- Top matte-textured eyeshadow or liners with an eye gloss, just as you would a lip color.

Primers and Mattifiers

Also called pre-bases, primers act as a screen between the moisturizer and foundation to create a smooth surface for makeup; they even out texture and minimize pores. A mattifier creates a uniform texture for makeup, too, but it also works to reduce shine, which makes it ideal for an oily skin. To prepare the skin and create the best base for the adherence of makeup, apply a thin layer to a freshly cleansed and moisturized face. Primers are also available for lips, and these versions not only moisturize and plump up lips, but also help prevent lip color from bleeding.

Sealing and Setting Makeup

Lip and eye sealants are lacquer products applied on top of the color to seal it in. However, the quickest and easiest way of sealing your makeup to keep it from disappearing during the day is to set it with powder. Once your makeup is complete, dip a large-size brush into loose translucent powder, tap off the excess, and lightly dust over your face. To avoid disturbing eye makeup, dust from the forehead to the chin and then horizontally across the cheeks.

Chip-free Nails

Follow this routine for a long-lasting color. First use a stain-guarding, strengthening base coat to even out nail ridges and imperfections, secure the color, and prevent the color coats from becoming stripy. Next apply two coats of nail polish, taking the color over the top edge of the nail and just beneath; this will help prevent the color from wearing away at the edge. Finally finish with a clear top coat to add glossy shine and protect the color from damage. Follow up with a fresh clear top coat every other day.

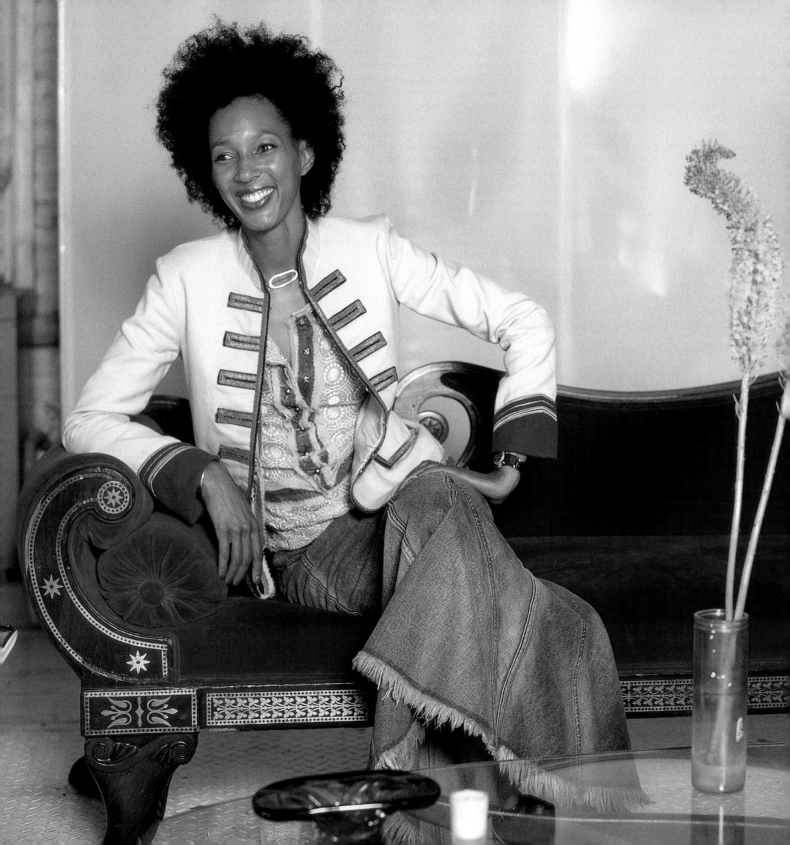

"I was always against having my eyebrows shaped, but once I had it done I realized how much it enhanced my face."

BROOKE WILLIAMS

BROOKE WILLIAMS, 35, is one of those people who are extremely talented at a variety of different pursuits. A photographer, songwriter, and part-time DJ, she is both stimulated and successful, managing to meld her work and play times into a fulfilling life of activity. Brooke, who photographs with a Polaroid camera, has two murals in her apartment. One is of all of the missing-person posters hung up around New York immediately following the attack on the World Trade Center. At first it looks like faces, and then as you move closer you realize that it is made up of a hundred portraits of people. As well as a haunting tribute, it's a testament to the scope of her talent.

> "I love the early summer, the first few warm nights when you unpack flirty summer skirts, say goodbye to a pasty complexion, and break out the flip-flops with, of course, a good pedicure."

Brooke loves to indulge in manicures and pedicures and brings up the point that they're one of the few truly luxurious beauty treatments that are reasonably priced. She loves the early summer, the first few warm nights when you unpack flirty summer skirts, say goodbye to a pasty complexion, and break out the flip-flops—enhanced by a good pedicure, of course.

Brooke pays more attention to her skincare routine, since her skin type has shifted from normal to oily now that she's reached her thirties. She also started having her eyebrows shaped. "I was always against it for some reason, but I had it done once and realized how much it really changes your face. I got so many compliments that I've been keeping up with it ever since." She used to have her hair straightened, but her curls are one thing she has long since accepted about herself. "I wanted to have my hair long and straight like the girl in *The Secret Garden*," she says, and she laughs at the memory, "but then I woke up one day and realized I was paying all of this money and it would take all day and I finally thought, 'Why am I doing this?'"

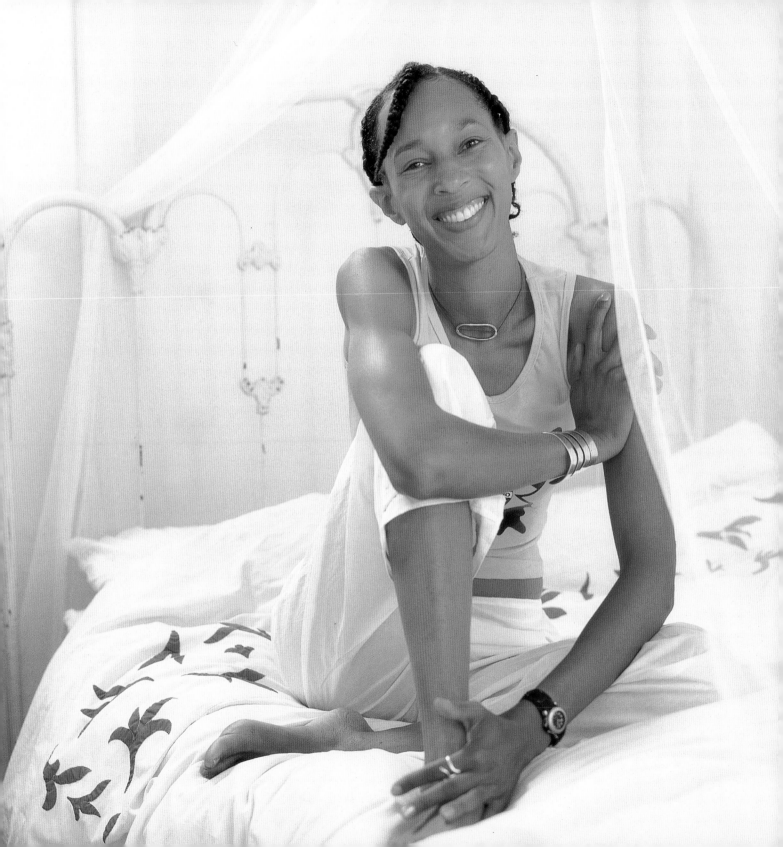

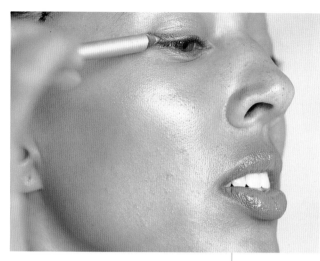

Yellow and Gold for Day:

To create a sheer, dewy finish on the skin, Brooke first applies a liquid foundation all over her face, which she then tops off with a cream gold highlighter on her upper cheekbones and eyes—this brings out the gold undertones in her skin. Brooke uses a combination of black and gold pencil liners to accentuate her eyes and add some funky color (see also page 94). The top of her eyelids are awash in a sheer metallic powder eyeshadow. On her lips she uses a spice-colored lip liner with a honey-gold gloss layered on top. Her nails match the honey-gold tones to create a perfect sheer manicure for day.

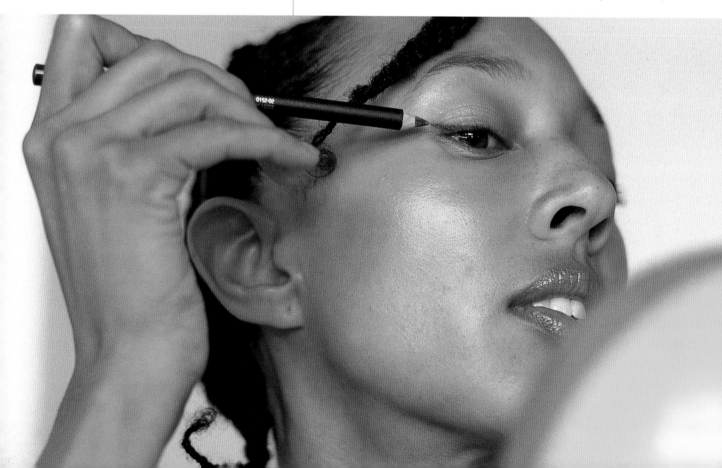

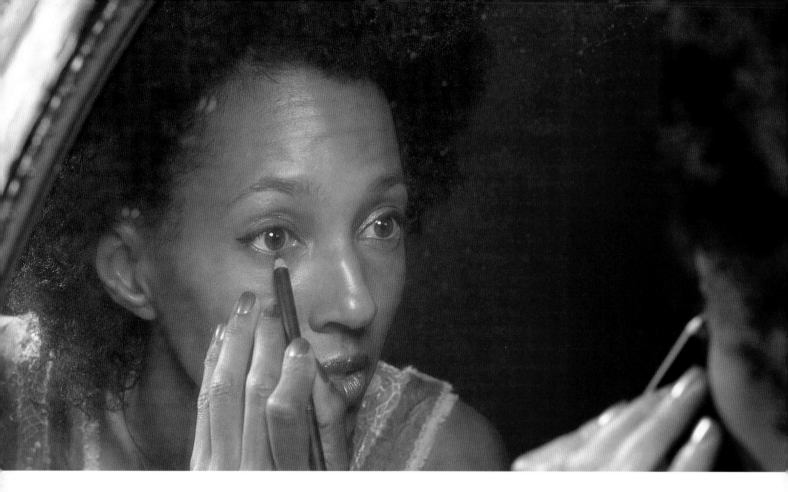

Yellow and Gold at Night:

For night, Brooke plays with more copper tones on her face. She adds a darker, more intense gold lipstick, with a touch of mocha. A little shimmer on the browbone and more highlighter on the apples of the cheeks are added for a sophisticated finish. On her eyes, a sheer copper eyeshadow is contoured in the crease of her lid. A sexy gold manicure finishes off the look.

"I wear red lipstick more often at night. It makes me feel like a grown-up."

Get This Look: ACCENTUATED EYES

Eyeliner can be tricky to apply, but will become a mainstay of your look with a little practice—just a thin line can add drama and definition. You can add flair with black liquid eyeliner or try out a mysterious, sultry look with a smoky gray smudged eye. Eyeliner is a great way to accentuate the whole eye in a way that can be either subtle or bold, depending on the application. While black eyeliner is a staple for most people, colors and metallics on the eyes create a fun and sexy look.

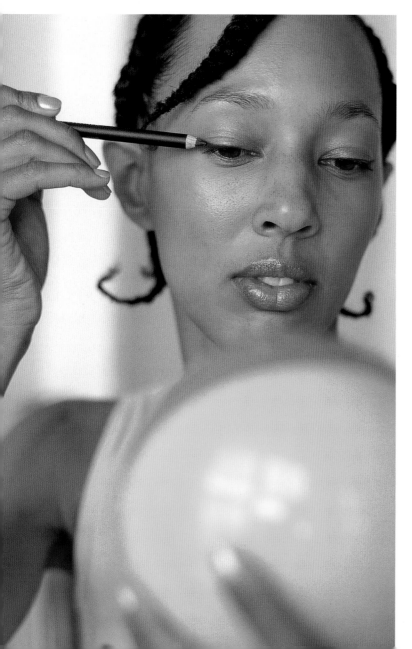

STEP BY STEP: PENCIL LINER

A pencil liner works well when smudged on the upper and lower lids to produce a smoky effect.

1 Gently pull the eyelid to create a taut surface for the pencil. You want to get as close to the rim of the eye as possible.

2 Start at the inner corner of the eye and work outward. For a smoky effect, gently smudge the line with your index finger or a makeup sponge.

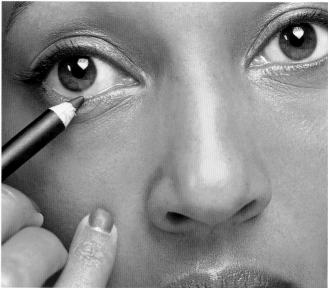

STEP BY STEP: LIQUID EYELINER

Liquid is best for a more striking accent. Given its definite capacity for drama, it is best reserved for nighttime or for when a formal made-up look is appropriate. Makeup artist Liza Zaretsky recommends using a small, pointed sable brush and making the line thicker near the outer corners of the eye.

1 Gently pull the outer corner of the eye away from the nose with your index finger. You want to get as close to the lid as possible.

2 Starting in the inner corner, work the wand outward toward the outer eye. Apply using a continuous smooth action so you do not break the line. You may like to tilt the applicator so the line on the outer part of the eye is thicker than the rest of the line.

TIPS

• When working with a liquid liner, have Q-tips (cotton buds) close at hand. It's easier to catch a mistake or a too-thick line before the liquid dries.

• To avoid dulling the line, apply liner after eyeshadow and any other eye makeup. Always apply mascara last.

• Start at the inner corner of the upper eyelid—this should be the thinnest line.

• If you choose to apply liner to the bottom rim of the eye, make this line thinner than the one on the top lid.

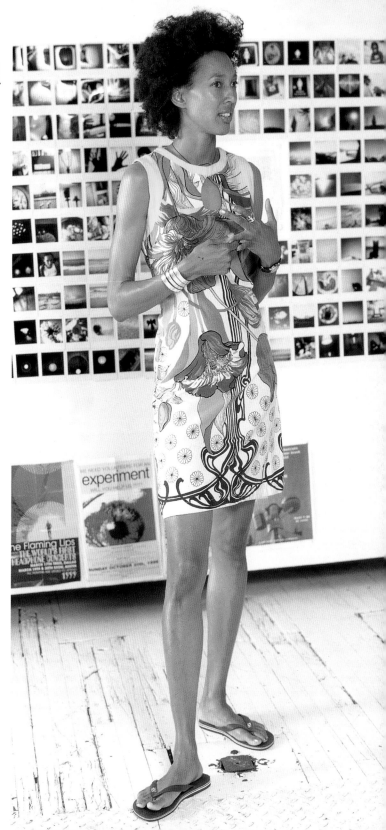

STEP BY STEP: WET/DRY SHADOW LINER

Wet/dry shadow is probably the easiest technique for most people. Any dark powder eyeshadow color will work. You will need a square-shaped brush with stiff bristles to provide the most natural look.

1 Dampen the brush lightly and press it into the cake or powder eyeshadow. Make sure the edge of the brush is well covered in color.

2 Pat the eyeliner brush to remove any excess shadow. Following your lash line, apply the color from the outer corner to the inner corner along the upper lashes. Repeat along the bottom to frame the eye.

STEP BY STEP: DOUBLE LINER

Two colors of liner worked side by side along the upper lashes offer a fun, eye-opening, and stylish look. Try pairings of one rich intense color with a metallic one, or alternatively try a jewel-bright color next to a darker one. Charcoal with silver, navy with gold, turquoise with black, and violet with gray are all good combinations to try.

1 Using a liquid or pencil liner in a metallic gold color, line the upper eyelids (see pages 92–93). Repeat under the lower lashes, if desired.

2 Using the darker color, line the upper eyelids only, just above the first line, flicking the color out at the edges.

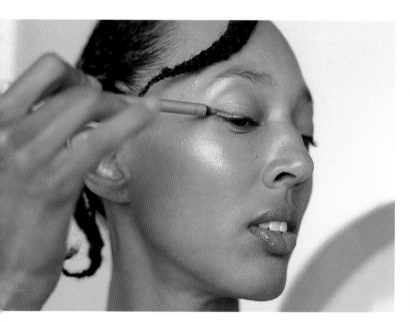

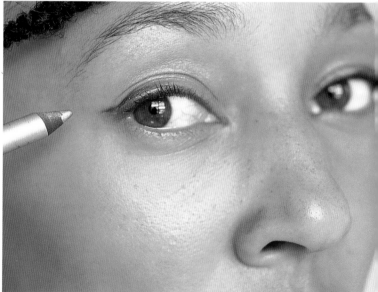

EYELINER GLOSSARY:

Liquid Eyeliner: While somewhat difficult to apply until you get the hang of it, liquid eyeliner—especially in black—is the ultimate makeup statement for bombshell beauties.

Pencil Eyeliner: A pencil provides a more subdued and natural look and can be used on the top or bottom lid.

Powder: Used with an eyeliner brush, powder provides a sexy look and is easy to apply.

Crayon: Softer in texture than eyeliner, a crayon offers slightly more flexibility and can be used as an eyeshadow.

Glitter: A glitter pencil is a great way to add sparkle to your lids or to line your eyes. Available in both soft and bold colors, and fine or large glitter particles, it is ideal for creating a party look.

Eyeliner Brush: This flat-tipped small brush should be dampened before using to apply eyeliner powder.

Yellows and Golds for Everyone

"Yellow eyeshadow is so underrated," comments makeup artist Liza Zaretsky, "and gold is so flattering, from a dusting of shimmery highlights to a rich body lotion subtly flecked with gold."

Blondes

A light gold shimmer or bright yellow works best on blondes, especially those with warm skin tones. Canary yellow on blue eyes makes them look turquoise.

Brunettes

GOLD WORKS WELL ON BRUNETTES, FROM A CHEEK SHIMMER TO A NAIL ENAMEL. GOLD ALSO BRINGS OUT FLECKS OF COLOR IN BROWN EYES. DARK-HAIR TYPES CAN TAKE THE BOLDNESS OF SUNNY YELLOWS.

Asian Skin

Women with yellow skin tones look fabulous in dark, mustardy yellows.

Redheads

Subtle yellows, like sand and corn, look best on redheads with delicate coloring. Pale lemons work well with hazel eyes.

Fair Skin

Fair skins with ivory, gold, or peach undertones can use hot yellows, while those with porcelain or pink tones should stick to pastel shades.

Olive Skin

Those with olive skin should use dark yellows with extra gold and brown undertones to avoid looking washed out.

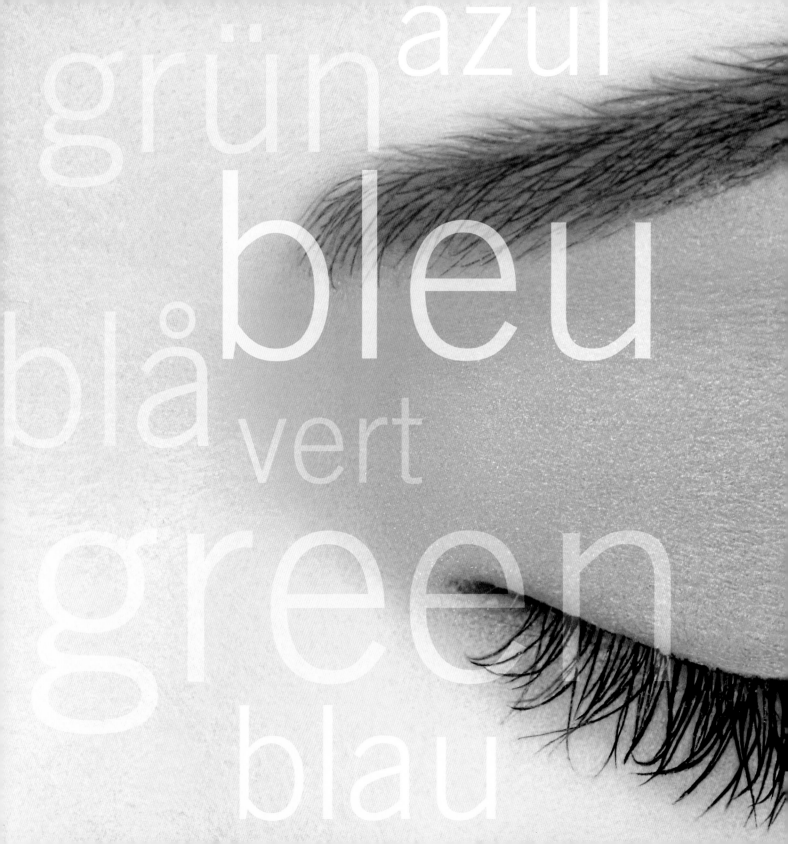

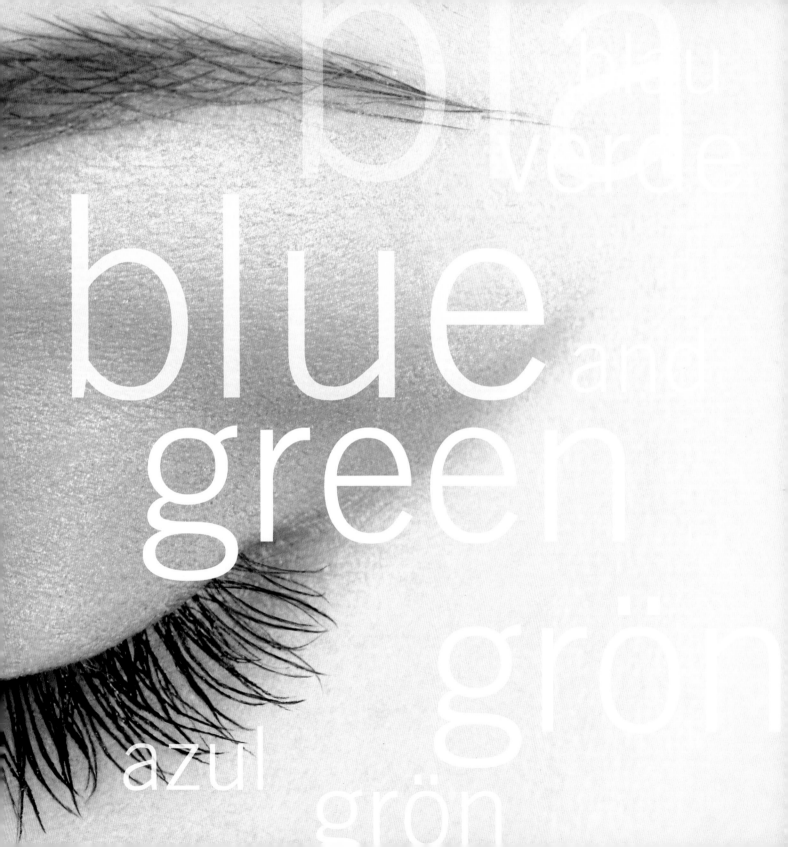

blue
green
azul
grön

Our Associations with Color

When we think of the color blue, water usually comes to mind, along with thoughts of tranquility and peace. Water and beauty make perfect companions, as many spa resorts around the world testify. Our bodies are composed of 70 percent water and need constant replenishment to maintain health. Another health-inspiring color, green signifies renewal, life, and the freshness of the great outdoors. It calls to mind vegetables and lush green grass, leading us to connect the color with nutrition. In fact, vegetables like broccoli, cabbage, cauliflower, and brussels sprouts are a rich source of antioxidants—so for a healthy body, inside and out, eat your veggies.

Water, the Life Force

- Experts agree that you should have eight glasses of water every day.
- Water is the ultimate facial. Skin needs water for elasticity, and lack of water leaves skin looking dry and feeling delicate.
- Sunken eyes and under-eye circles are the tell-tale signs that you need water. Dark circles are due to thin skin being bruised as fluid drains away.
- Water helps to prevent the sagging skin that usually follows fat loss. It plumps up the shrinking cells and leaves the skin clear, healthy, and resilient.
- Water aids concentration. Your body needs water to help flush out poisons from pollutants, junk food, and additives. If you are dehydrated, toxins hang around in the liver, making you tired and unable to concentrate. Water washes the poisons out and gets the system moving.
- Water both prevents and remedies fluid retention. When you're feeling puffy, as women often do before a period, drinking water isn't your immediate thought, but it is the best treatment.
- Water is a great headache cure-all. Three-quarters of your brain is water, so if you're dehydrated, the brain is one of the first organs to be affected. Drinking eight glasses of water a day will usually prevent dehydration. If you are a migraine-sufferer, there is also evidence that drinking a glass of water every 30 minutes will reduce attacks.

An Antioxidant-rich Diet

• Antioxidants rid the body of free radicals, helping to delay the signs of aging, boost the immune system, and protect against cancer and heart disease.

• A diet high in antioxidants protects against the damaging effects of environmental toxins. Studies comparing different populations have shown that increasing fruit and vegetable consumption may reduce the risk of developing chronic bronchitis.

• Green vegetables contain varying amounts of potent phytochemicals such as lutein and indoles, which are thought to have great antioxidant, health-promoting benefits.

If You Like Green:

Green-lovers are seekers of balance and harmony. Kind and generous, their perception and awareness in relationships are good, so it's not surprising that they are great joiners of clubs and organizations. People who like green are said to be meticulous about detail, and certainly you will have an enviable ability to recognize the essentials of any situation. The downside is that green-lovers dislike sudden surprises, so they may be less inclined to risk something new and may tend toward conventionality and routine. They also often have big appetites for food—and for gossip. If you love the color green, experiment with shadows and liners, combining subtle, soft shades of mint and earthy tones around your eyes.

If You Dislike Green:

Since lovers of green are usually very sociable people, those who dislike green tend to be resistant to the established way of seeing or doing things. They may have an unfulfilled need to be recognized that causes them to pull away from, rather than join, people. Essentially, they march to the beat of their own drum and follow their own path.

If You Like Blue: The color of calm and peace wins out as

the favorite color choice universally. Although apparently cool and confident, blue-lovers can sometimes be vulnerable and sensitive. They have a great need for trust and the tendency to form strong attachments. Betrayal is the worst hurt. In consequence, people who like blue tend to stick to their own close circle of friends and are less likely to speak out or act independently. The blue personality sometimes has perfectionist tendencies that can make these individuals unrealistic and demanding in their relationships with others. If you are in the majority and love the color blue, there are many ways to incorporate it into your beauty regime. Try a sultry midnight blue eyeliner or a dusty blue shadow on the lids. Sapphire mascara is also fun.

If You Dislike Blue: A dislike of blue may mean restlessness

and a desire for stimulation and excitement. These types often have a longing for the good things in life and wish they didn't have to work so hard to get them. To these people, blue represents sadness, and the color may induce melancholy.

ColorSense

BLUES AND GREENS ARE STRONG COLORS, AND SO YOU MAY BE WARY OF USING THEM, BUT ADDING JUST ONE TO YOUR EVERYDAY PALETTE OF NEUTRAL EYESHADOWS CAN FRESHEN UP YOUR LOOK. CHECK OUT THE ADVICE ON PAGES 120–1 TO FIND OUT WHICH SHADES WILL SUIT YOUR SKIN AND HAIR COLOR BEST. FOR EXAMPLE, SHIMMERY BLUISH-GREENS LOOK GREAT ON PINK-TONED SKIN BUT WON'T SUIT EVERYONE, WHILE KHAKI AND DEEPER GREENS ARE MORE UNIVERSALLY WEARABLE. TRY BLENDING GREENS OR BLUES WITH PINKS AND CREAMS ON THE BACK OF YOUR HAND TO FIND A COMBINATION THAT YOU LIKE.

Make sure that you remember the makeup mantra: if you are wearing a bold green or blue color on your eyes, keep your cheeks and lips understated in barely-there hues. For example, you can balance a glossy jade or azure eye color with glossy nude lips or highlighted cheekbones for a radiant, glowing look.

Bold blues and greens accentuate features, so be careful where you use them. Don't wear a vibrant green eyeshadow high on the browbone (the rule applies to bold blue, too). Instead, experiment by combining green shadows with golds or silvery grays, deepening the green into the crease of the lid and extending the gold or silver onto the browbone as a highlighter.

Try using turquoise eyeliner or navy blue mascara to bring out the whites of your eyes—this is a great way to refresh a tired face.

"An optimist is a person who sees a **green light** everywhere... **"**

ALBERT SCHWEITZER

inspirations

Inspire some green-eyed envy by using a deep olive or hunter green eyeshadow to intensify green eyes. And if your eyes are blue, try a smudge of sapphire or cobalt over the lid, with a paler blue shade blended on the browbone and inky indigo mascara on the lashes.

Want to be more productive, ambitious, or reliable? Choose blue, because all these qualities are associated with the color. Wear a steadfast "true blue," though, such as navy, ultramarine, or royal blue; alternatively, for a softer romantic appeal, choose shades like teal, powder blue, or turquoise.

Green and blue are relaxing and soothing, so experiment with these colors when you're on a vacation. Try sea blues for the beach or soft greens for the countryside. Bright blues or greens—colors that bring out a tan—look enchanting on sandaled toes in the summertime.

Celebrate the healing power of color with verdant greens, colors that signify health and regeneration. Go for the natural look with grass, apple, moss, or sea green shades of eyeshadow, or try jewel-bright jade or emerald.

"In a way, the fact that my hair was different allowed me the freedom to experiment with striking, colorful makeup—like bold blues and bright greens—I wasn't stuck in a box."

ELIZABETH SEKLER

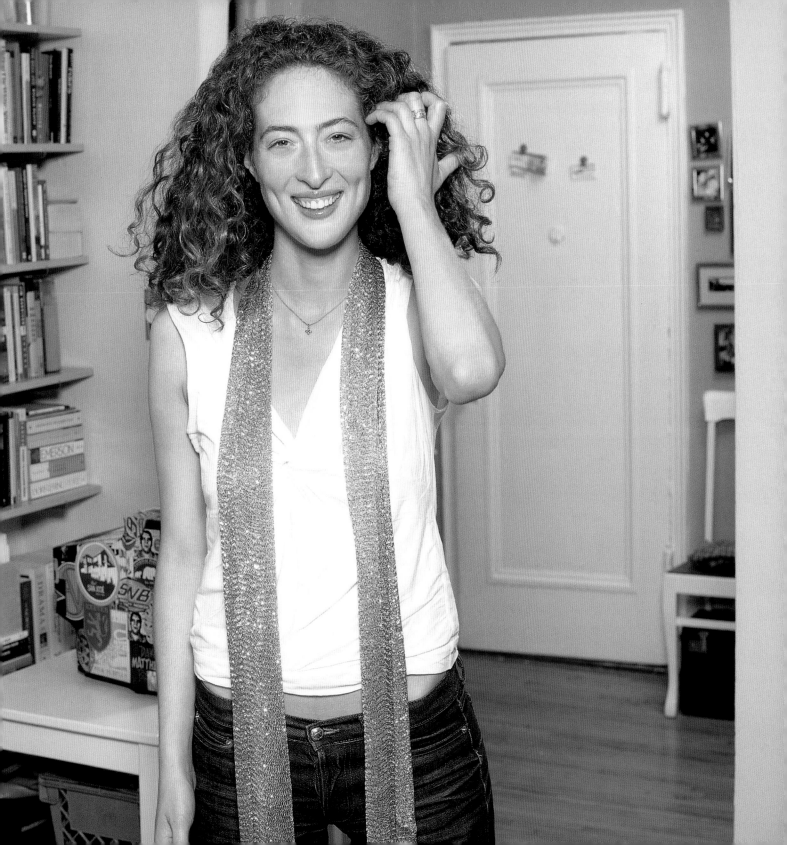

ELIZABETH SEKLER, 30 and a full-time mom, loves to wear strong, graphic makeup. To look at her now, with her wildly thick mane of sexy red hair, perfect skin, and ebullient mannerisms, it's hard to imagine the girl that used to struggle with what is now considered her best feature. "I so badly wanted straight, blonde hair—I was ridiculed, you can't imagine."

"When I was really little everyone would wear those little lamb or duck barrettes—I could fit like four hairs in one," she laughs. Her beauty routine has evolved, thankfully. "I do a mask every once in a while and take a sauna whenever I can. I always use a refreshing moisturizer after the shower. And I try to do something nice for my face every morning."

> **"** I do a **mask** every once in a while and take a sauna whenever I can. I always use a **refreshing moisturizer** after the shower. And I try to do **something nice** for my face every morning. **"**

Elizabeth speaks with ease and comfort, she throws her head back when she laughs, and she seeks out a personal connection in conversation. Her perfect waistline belies the fact that she has 20-month-old son. He has the same coloring, the same striking red hair. "I loved being pregnant—from three to seven months is when I felt the most beautiful. The other times could be a bit rocky." Elizabeth grew up with two older brothers, and though she loved to experiment with makeup and liked to dress up, her inner tomboy kept sneaking up: "I wanted to be a girly girl, but I was constantly dirty, falling down, and bruising my knees."

Elizabeth Sekler with her son Jozef Mahoney ▶

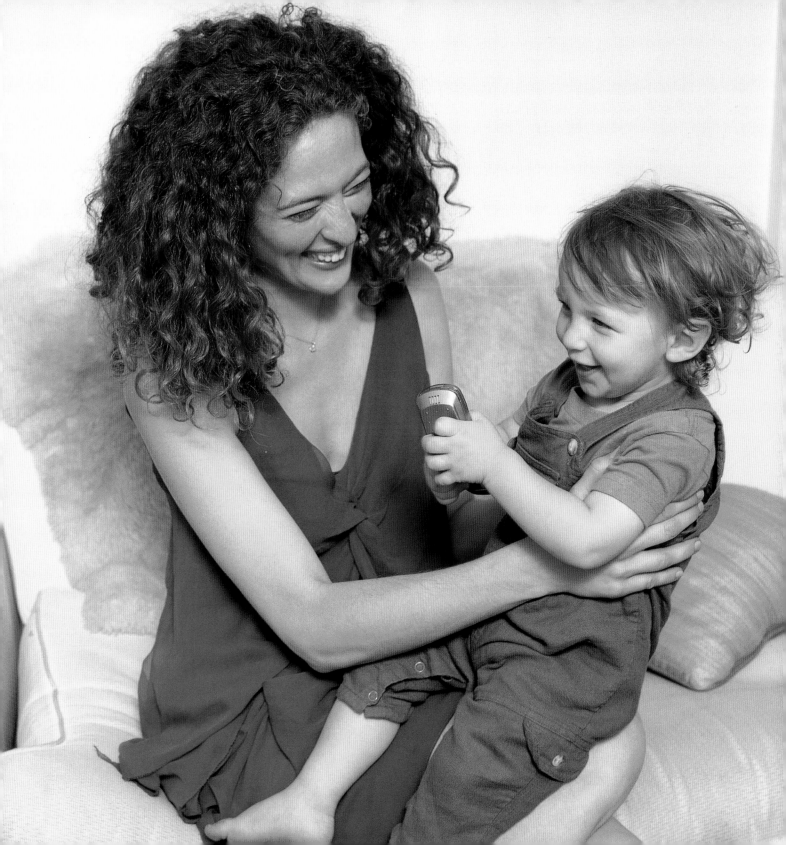

Blues and Greens for Day:

For her daytime look, Elizabeth applies a sheer veneer of concealer only in the area where she feels she needs it. "It's no longer about the old-fashioned mask of foundation. You want to see your skin, and, in Elizabeth's case, her freckles and a natural skin tone through the foundation," confirms Molly Stern. Next, Elizabeth applies a cream eyeshadow using her ring finger, because that gives the least and gentlest pressure (the skin around the eyes is the most fragile area of the face). She works from lash to crease, fans it out, and blends it into the browbone. Then she curls her eyelashes and adds mascara to give the eye a much more open appearance.

During the day, for trips to the park with her son, Elizabeth chooses a pale palette of nudes and neutrals for her lips.

" Elizabeth's red hair and fair complexion are the **perfect canvas** for a palette of blues and greens. **"**

makeup artist MOLLY STERN

Blues and Greens at Night:

For nights out on the town, Elizabeth uses the same spare foundation technique as for daytime, applying a cream blush under the apples of her cheek to create a "natural blush." She intensifies her shadow by placing a deeper blue on the outside corner of her eye and a bronze eyeliner along the top rim of her eyelid. She lines her lips with a nude lip liner for definition and adds gloss with a bit more color. Finally she curls her eyelashes and adds two coats of black mascara.

Eyeshadows: Cream vs. Powder

Cream eyeshadow provides a dewy, sheer look. It can be light or dark in color but has a more blendable quality than powder. Its sheer consistency lends itself to a natural look. But cream eyeshadow can also be dramatic or sultry, if you play to its glossy appearance.

The downside to cream is that it needs more upkeep—it tends to settle into the creases of eyelids. But touch-ups are not difficult. They don't even require added color. Just gently dab the ring finger over the eyelid to even and smooth out the shadow.

Powder eyeshadow is for the woman who doesn't have time to touch up her makeup. Its matte, denser look is dramatic. Like pastels and charcoals in fine art, powder is perfect for contouring and shading and can be applied with a makeup brush. Natural hair is best.

First cover the surface of the lid with the lightest color, using a flat-tipped brush. For contour, add a darker shade in the crease and highlight the browbone with a lighter color, applying it with a more pointed brush and then using the flat brush to blend and fan out. A tight, sharp brush is perfect to line eyes for more definition.

If you're not adept at using makeup brushes, use a sponge applicator to apply and then blend with your fingers.

TIPS

• Dust your ring finger with a loose translucent powder before applying cream eyeshadow to your eyelids, so you don't mix finger oils with eye oils. This also creates a matte effect.

• Cream and powder can be combined for serious staying power. Cream should be used as a base and the powder to set. Even light tones take on a more opaque look.

Get This Look: **LUXE LASHES**

If eyes are the window to the soul, eyelashes are the crucial draperies. But while curling and applying mascara can accentuate the eyes or achieve some desired look, they can dry out lashes if used without proper care. Always remove mascara with a conditioning eye makeup remover before cleansing your face, and avoid tugging the skin. Contact lens wearers and others with eye sensitivities should wear hypoallergenic or specially formulated mascara for sensitive skin. And though waterproof mascara is at times a necessity—think of your best friend's wedding or a day at the beach—be aware of its drying effect. If you notice your lashes seem to be drying out, or your mascara begins flaking, reserve waterproof mascara for special occasions.

STEP BY STEP: CURLING LASHES AND APPLYING MASCARA

Eyelash curlers are the best—and that means cheapest and simplest—way of curling your lashes, and once you get past the decidedly torturous appearance of the curler, which can be somewhat intimidating, it's a breeze.

1 Open the curler, position it directly over an open eye, and look down. Once the upper lashes are in place, close the curler, and hold it carefully in place for about 5 seconds.

2 Gently open the curler and remove from the eye area. Repeat the procedure on the other eye. To achieve an even greater effect, curl the lashes twice.

3 Apply mascara, working on the upper lids and from the outer to the inner corner of each eye. Color the bottom lashes slightly if under-eye darkness is not a problem.

4 Focus on keeping eyelashes separated. In most cases you'll need one to three coats to achieve the desired thickness. Let each coat dry before applying the next to avoid clumps.

TIPS

- Never apply mascara before using a curler on the lashes. Make sure that the eyelashes are clean before you curl, but apply all other eye makeup—liner, shadow, shimmer—first.
- Don't keep mascara too long. Experts recommend discarding every four to six months to avoid the buildup of potentially harmful bacteria.
- Blue or green mascara is always fun on those with fair skin or light eyes. But for a more subtle look, top off a coat of black mascara with just the merest hint of blue edges.

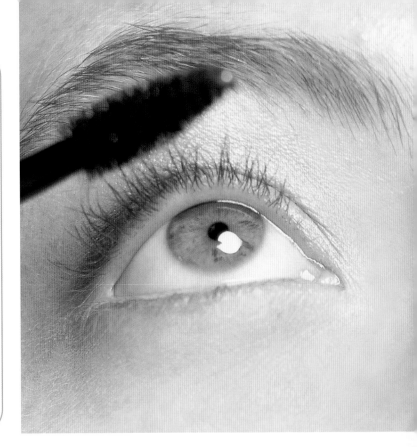

MASCARA GLOSSARY

Darkening: Adds depth to the eyes. Especially useful for fair-skinned and light-haired people.

Lengthening: Contains tiny fibers to extend and elongate lashes.

Curling: Adds flair and shape to lashes.

Separating: Eliminates clumps by combing color through the lashes to enhance every lash.

Extra Thick: Adds volume to sparse lashes.

Water Resistant: Won't smear or wash away until the moment you decide that it's got to go.

Long-Wearing: Provides dark, natural-looking lashes for an extended time without smudging.

Curved Brush: The brush mimics the natural shape of lashes, making even application much easier.

Get This Look:
PERFECTLY POLISHED TOES

The pedicure, the queen bee of all beauty treatments, is one that not only makes you feel completely pampered but leaves you looking fresh and fabulous. It is hard to name anything that's as good as having luxurious exfoliants scrubbed into your heels and calves, followed by a relaxing foot massage, and then finally stepping out with some glossy, color-of-the-moment nail polish. A pedicure really gives you that feeling of being groomed from top to toe. And if strappy summer sandals are part of your game plan, what would they be without the perfect pedicure?

TIPS

• For extra softening, or just as a treat, smother tired feet with moisturizing foot cream before you go to bed, and put on protective cotton socks overnight.

• Be more experimental with pedicure colors—bright and unusual colors that may not be appropriate for hands are perfect for feet.

• Better bare toes than polish that's barely there. No time for a pedicure? Remove old color completely rather than walking around with chipped polish.

STEP BY STEP: PEDICURE

Caring—softening, cleaning, tidying—is the keynote of this classic beauty treatment. Healthy, happy feet are central to well-being: if they feel good, you'll definitely walk taller.

1 Fill a large basin with warm water for a long foot soak. You can add rosewater or essential oils for deep relaxation, as well as to soften calluses and corns.

2 Clean under toenail tips and then clip. File splits or rough edges. Using an emery board, work carefully in both directions to smooth away tears or breaks. However, if you use a metal file, work in only one direction.

3 Rub cuticle remover into nail beds. If you want to trim cuticles, do so carefully and sparingly with sterilized trimmers. Better yet, just push cuticles back with a manicure stick and clip any hangnails.

4 Using a skin file or loofah, remove dead skin from soles of feet, zeroing in on heels and balls of feet. Pumice stone also removes calluses and dry spots. Massage an exfoliant cream into the skin, rubbing it all the way up the calves. Rinse off, and then apply a moisturizing lotion especially made for feet.

5 Apply a neutral base coat to fortify and protect the nails. If your nails are prone to chipping and splitting, use a base tailored to these needs. Then apply two coats of your chosen color and a clear protective top coat. Allow to dry thoroughly.

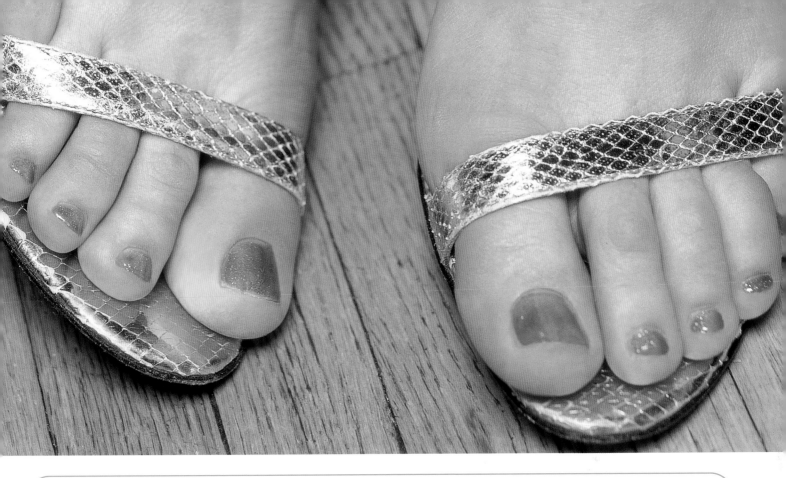

NAIL ENAMEL GLOSSARY

Base Coat: A super-fortifying vitamin-packed base coat prevents splitting and breakage.

Strengthening: An added-benefit base coat that enhances nail health and helps to prevent chipping and splitting.

Top Coat: A shiny, lustrous top coat of clear polish seals in the polish and adds shine.

Quick-dry Enamel: For a pedicure on the go, this speedy polish dries in 60 seconds.

Iridescent Enamel: Multidimensional shades create a "prism" effect that changes color with movement.

Glitter Enamel: Colored glitter particles, suspended in a clear base, can be used over bare nails or color.

Blues and Greens for Everyone

There's just one steadfast rule when using strong colors such as blue and green. Limit yourself to a single bold statement; so, for example, when you decide on a palette of blue or green eyeshadow, play down the rest of the color on your face. That said, do whatever feels right while taking into account what you're wearing and the time of day, in addition to your hair and skin color. And don't forget the fun factor.

Blondes

Blondes and those with fair skin have to be a little cautious with brighter blues and greens to avoid overpowering delicate coloring. Navy liner is a classic, sophisticated choice on a palette of sheer pastel hues and pale opaque tones.

Brunettes

BRUNETTES CAN BE FREE WITH COLORS SUCH AS EMERALD AND TURQUOISE. THE CONTRAST WITH "NEUTRAL" BROWN HAIR CAN BE BOTH ARRESTING AND SEXY.

Dark Skin

Dark-skinned women have the most freedom with bold colors. From wilder, brighter tones like teal or emerald, for a funky, dramatic look, to classic navies and hunter green, these colors work well.

Olive Skin

WOMEN WITH OLIVE SKIN CAN LOOK SALLOW WITH THE WRONG SHADE OF GREEN, SO CHOOSE WISELY. AVOID THE MEDIUM BLUES, USING BLUES WITH A LIGHT TONAL VALUE OR DEEP, RICH TONE.

Redheads

Earthy greens look best with warm-toned redheads, while cool blues and aquas suit those with a pinkish complexion.

Asian Skin

Blue tends to counteract yellow tones in skin. Makeup artist Molly Stern explains, "Green is more neutral than brown on skin with yellow undertones. Olives and yellow-greens look great on Asian women and can work in place of brown and taupe."

a purple and lilac

mauve

púrpura

lila viol

lilac

lilac

Our Associations with Color

Colors often seen in nature, purples and lilacs evoke a sense of smell more than actual images. We have so many names for the shades of this romantic color, which can range from the pinkest mauve to the blackest violet. Purple is often associated with royalty; in fact, in the Middle Ages purple dye was the most expensive to make, so it was used only on the robes of royalty and priests.

The scent of lavender near your bed promotes sleep and eases insomnia; it also relieves stress and nervous tension.

Lavender

• Lavender has long been thought of as a romantic color, yet it's widely used to heal the body and spirit, as well as to woo the heart. When used in aromatherapy, the spicy smell of lavender in essential oil or floral water induces relaxation, calm, and peace, and so it is a wonderful aid for de-stressing, which can contribute to keeping the heart healthy.

• Lavender oils, hydrosols, and even the blossoms themselves can be used in cooking to add a subtle flavor to food.

• The benefits of lavender have been known since the Middle Ages, when the disinfectant powers of the flower were discovered and the petals were added to bathwater. Convinced that epidemics spread through smells, the people of the time burned lavender in the streets and in their houses. Trade in the essence began during the Renaissance.

• In the traditional medicinal practices of Provence, lavender was used to soothe, disinfect, and heal wounds. Today, the most advanced scientific laboratories have analyzed the herb's powers in detail and confirmed its therapeutic reputation. It has indeed been proven to aid relaxation, help relieve anxiety and depression, work as an anti-inflammatory, help heal cuts and burns, and balance both body and mind.

Flower Essences and Perfumes

In Grasse, France, fields of lavender, along with many other herbs and flowers, are harvested and made into some of the most famous fragrances in the world. Flower essences infiltrate all cosmetic and skincare products, adding to their sense of luxury. Fragrance is grouped into four basic categories: floral, woody, fresh, and spicy, and the types of perfume, in order of staying power, are: cologne, eau de toilette or eau de parfum, and perfume. Every perfume is constructed of a base note, a middle note, and a top note, which is the one you smell first but lasts the least amount of time—roughly just 15 minutes. Whatever blend you use, don't apply too much scent on your pulse points. This will make the scent overpowering at first but quick to fade. Instead, spray a mist of perfume into the air and walk through it so it covers you like a veil.

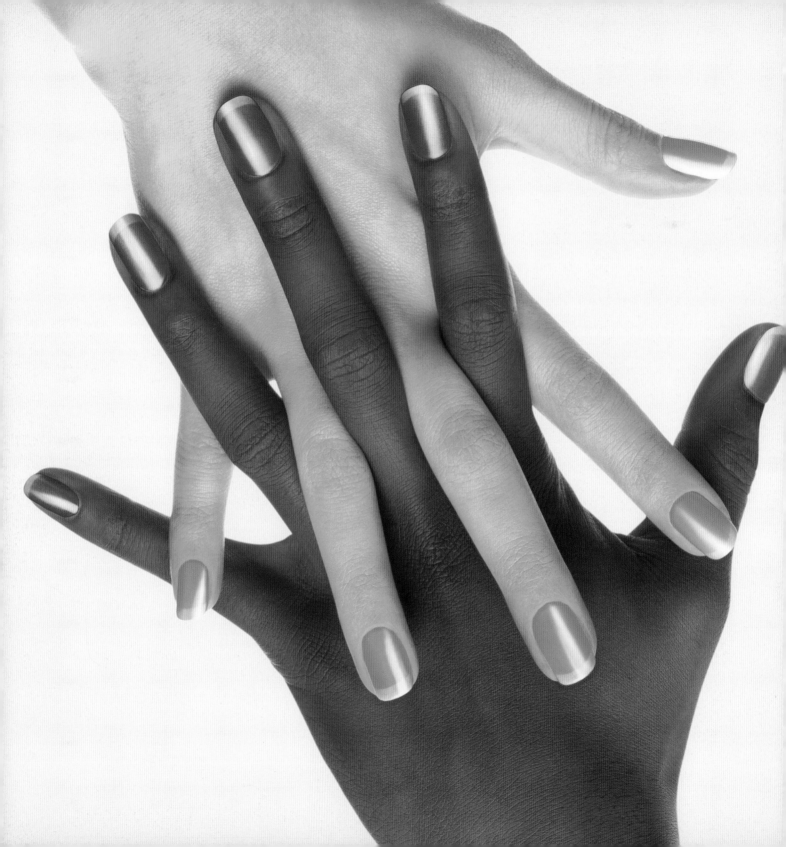

Purple is sexy, sultry, and sophisticated at the same time as being regal, grand.

If You Like Lilac and Purple: This hue has an aura

of intrigue and mystery, and the purple-lover is often an enigmatic and highly

creative individual. Purple is the color choice of the artist and those interested

in spirituality and mysticism. Those who prefer lighter shades, such as lilac or

lavender, are true dreamers who can't stand the sight of ugliness in any form.

The way things look and seem is extremely important to them. Sentimental

leanings also go along with this color, as do romantic emotions. If you love

purple, try out a blackberry lipstick, smudging it on with your finger for a stain

effect, or use a sheer lavender mixed with a deep mulberry on your eyes.

If You Dislike Lilac and Purple: These

individuals approach life with a no-holds-barred, time-is-money philosophy.

They are usually direct and tell it like it is. Focused and go-getting, these

personality types may have little tolerance for others who daydream or who

are not as dedicated or as no-nonsense as they are.

ColorSense

PURPLES AND LILACS ARE FEMININE COLORS BUT DO HAVE DIFFERENT PERSONAS. DEEP PURPLES CAN BE VAMPISH AND GOTHIC, IDEAL FOR CREATING A SULTRY EVENING LOOK, WHEREAS SOFT POWDERY LILACS GIVE A DELICATE PRETTINESS THAT SUITS FLIRTY CLOTHES AND SUMMERY DAYWEAR. THE GREAT THING ABOUT PURPLE IS THAT, BECAUSE THERE ARE SO MANY SHADES TO CHOOSE FROM, YOU ARE CERTAIN TO FIND ONE THAT SUITS YOUR PERSONALITY.

From dusty lilac to sultry plum, shades of purple look sophisticated everywhere. The right shade is surprisingly easy to wear once you find the appropriate undertone for your skin, but don't overdo the color. Neutral cheeks and lips balance out a deep violet on the lip; alternatively, add a hint of purple mascara to the edges of eyelashes for a touch of color.

Incorporating purple into your lifestyle can lift your spirits and bring some positivity into your day. Try spraying lavender water on a love note or picking bunches of lilac blossom and placing them all around your house.

For the summer months, choose soft shades of pinkish and bluish purples, such as lilacs, mauves, and orchids, but go for redder shades of purple, plum, and violet in winter.

Glide on clear, translucent purples to create a fresh face that is washed in the lightest hint of color. Transparent purples, which tend to look surprisingly dark in the container, are available for the cheeks, lips, and eyes, and often sold as all-in-one sticks. These are great for boosting radiance and creating a glowing base. A little glossy purple or frosted lilac on the eye needs a coat or two of mascara to set it off.

Cleopatra loved the color purple and had her servants soak 20,000 **Purpura snails** for more than a week to get an ounce of purple dye.

inspirations

With its calming and soothing qualities, lavender is easy on the eye and a good color to wear when you feel the need to de-stress and wind down.

Purple evokes passion and intrigue and is associated with both sensitivity and sex appeal, so the color may give you just the right mix to work magic on the opposite sex.

Get others to treat you like royalty. Long associated with nobility and high rank, purple is a good choice to wear when you want to take charge and gain respect.

Purple is rare in nature, which makes it an exquisite and sought-after treasure. To similarly single yourself out as a rare beauty, use the flower shades of hyacinth, violet, lilac, and lavender for eye and cheek colors.

Signifying luxury and wealth, purple can sometimes seem a little unattainable or artifical, which makes it perfect for a sophisticated look but not as good for an all-natural style.

AGE-RELATED MAKEUP

Different times of life require different approaches to makeup. If you find that you are still using the same techniques and products you used ten years ago, it is time to consider a change. Your skin tone, texture, and coloring, not to mention your hairstyle and the clothes you wear, will have altered somewhat in that time, and so should your makeup. Those of you who don't need to take into account the passage of time will face other makeup challenges: perhaps you've never established a makeup routine, are confused about the options available, or are still experimenting with your look. Some women are definitely "lipstick girls" while others are "eye girls," and you may find that you fit into one of these categories. If you don't, though, you can be as eclectic as you dare. However old you are, you should try to discover which features you should exploit—really knowing yourself is the key to your image.

Teens and Twenties

- Try the pale lip/dark eye look—it looks terrific and modern on young complexions.
- To conceal blemishes, dab on toner and then paint on the concealer with a brush and dust with powder to set; alternatively use a special concealer for covering up and treating blemishes.
- Avoid heavy foundation. A concealer just where you need it or a tinted moisturizer will let your naturally glowing skin shine through—freckles and irregular nuances included (it's what makes you you).
- Experiment with metallic and glittery finishes and electric-bright colors—just because you can get away with it. However, avoid this as a daytime look, or you may not be taken seriously.
- Don't try to accomplish too many looks at once. Consider how your makeup ties in with your clothes, hair, and lifestyle, but be flexible, too. Don't be afraid to make a choice and go with it one day, only to try something different another time.
- Keep in mind that good basic grooming—clean skin, tidy brows, and moisturized lips—is the foundation on which a good makeup look is built.

Thirties and Forties

• Use a radiance booster—a moisturizer that imparts luminosity—before applying makeup to perk up a dull skin tone.

• Dab highlighter on the cheekbones and browbone for a youthful and dewy-looking glow.

• To hide dark circles, apply a light-reflecting concealer with a wand or brush on only the worst area of the circles. Let it set for a moment and then blend it in. Do not try to cover the whole area or else the technique will look obvious.

• To disguise red capillaries, apply a concealer over the area using a rocking motion with the fingertip to lock it in place.

• Capture a fresh, natural look by lining the eyes with a white eyeliner and adding a dot of highlighter to the inner corner of the eyes to bring out a wide-eyed look. Avoid dark liner along the lower lashes.

• Simulate the effect of fuller lips by dotting the center of your top and bottom lips with a high-shine gloss.

• Adapt makeup trends by diluting them. You are young enough to get away with trendy looks, but use them in a subtle way; for example, instead of black-rimmed eyes, use a navy liner alongside a shimmery silver that will simultaneously lift the eye.

Fifties and Over

• Use lightweight foundation; fragile, thinner skin and wrinkles can't hold the weight of a heavy base.

• Add shine or gloss in the inner "v" corner of the eyelid, and use a highlighter on the brow and in the center of the lid.

• Apply gentle layers of eye color in peaches and cream or rose and soft gray.

• Avoid heavy, dark eyeshadow colors, which make eyes recede. Instead choose silvery grays and pastels, peach with honey taupe, or soft lilacs and periwinkle blue.

• Blend soft shades into the crease of the eye, and then add a scattering of sparkle to the face—a shot of gold on the lips or dusted over the eyes gives a modern twist to subtle makeup.

• Curl lashes to open up the eyes, which can seem smaller as you get older.

• On lips and cheeks, opt for soft makeup shades, such as corals, apricots, and peaches, to brighten the complexion.

• If you've lost color and lips have faded, add color back in with rosier, healthy-looking shades of blush and lipstick.

• Avoid dark colors on lips, which will make them appear smaller and thinner, and invest in a natural-colored lip liner.

• Don't put any shimmer or highlighter where you have lines and wrinkles, or else it will draw attention to them.

• Use only a light coat of powder—like foundation it can settle in wrinkles and creases.

"For a night out, I like to use darker colors like plum and violet, along with black eyeliner."

MARTA GARCIA

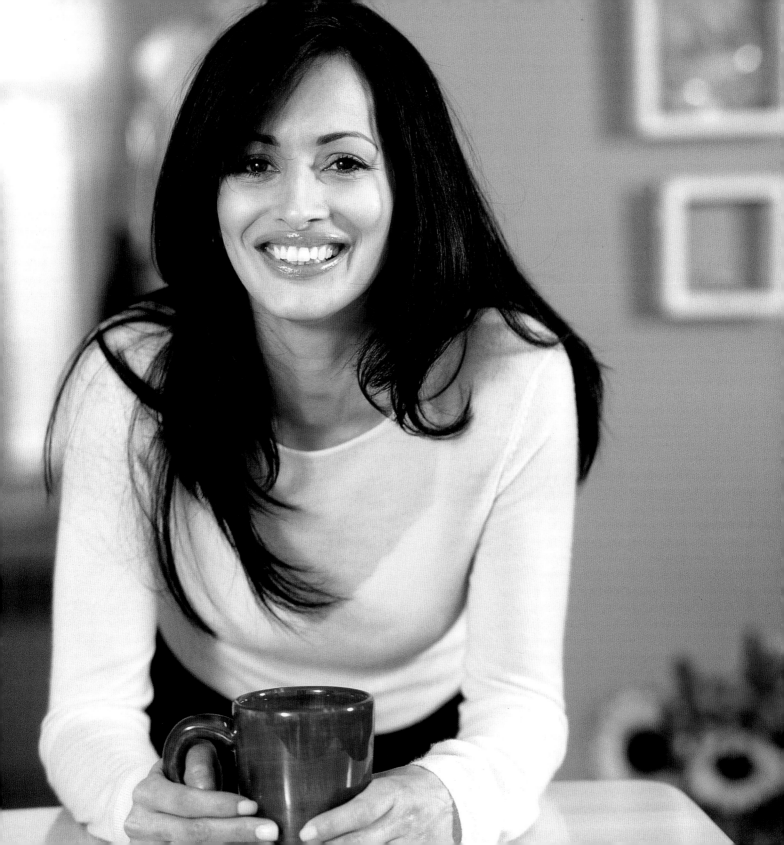

MARTA GARCIA is 36 years old and has the youthful and healthy good looks of a woman who is confident and wise and clearly takes care of herself. The mother of two girls, she has passed on her spare beauty routine and penchant for healthy living to her daughters. "I hardly wore any makeup at all through my twenties, and now my oldest daughter, a teenager, prefers the natural look as well. And she eats right, and we exercise together. I encourage her to stay out of the sun. She already applies sun protection," Marta says proudly.

> "You have to make time for yourself alone. Women are trained to take care of everyone else first, but you have to treat yourself well, too. You deserve it."

But their pared-down beauty routine doesn't stop them from fighting over the bathroom they all share: "Of course we do, are you kidding me?" Marta washes her face in the morning with cold water and uses a toner as an astringent. For nights out with her boyfriend, who she says is a partner in healthy eating and exercise, Marta uses darker colors like plum and violet on her eyes, along with sexy black eyeliner.

She has an infectious inner peace that she's willing to share, and she's at the ready with advice about motherhood, career, and life in general for anyone who asks. Being a woman in a male-dominated field (Marta is in investment banking) as well as a single mother, Marta certainly has a full plate. How does she make it look so easy? "You have to make time for yourself alone. Sometimes at night I recharge on my own with a good book, or spend the day in a garden. Women are trained to take care of everyone else first, but you have to treat yourself well, too. You deserve it."

Marta Garcia with her daughters Kiana and Shevonne Hernandez ▶

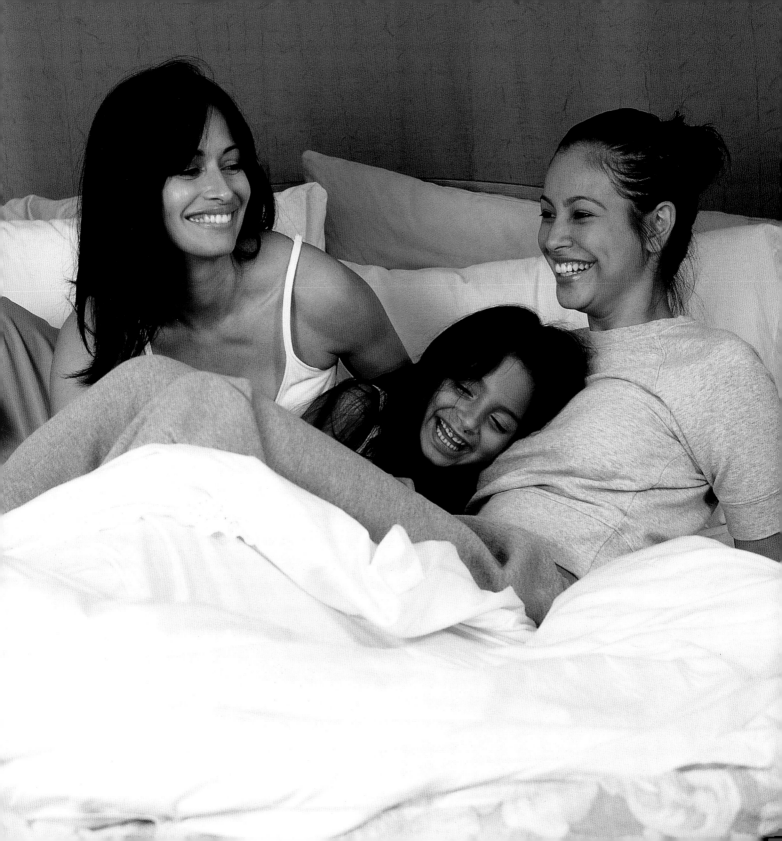

Purple and Lilac for Day:

As an investment business representative, Marta favors a professional, clean, groomed look during the day. She applies concealer and a sheer base, and then evens out her skin tone with a pressed powder for a polished look. On her lips she uses a plum-colored liner and smudges it, filling in the whole area of the lips, not just the outer lines, to give her lipstick more staying power. Marta dots a cream blush in a shade of berry on the apples of her cheeks, which works well on her olive complexion. She uses a sheer violet wet/dry eyeshadow in just the right amount of color for her eyelids, and sparingly applies a smoky black eyeliner at the roots of the lashes, which she then tops with a coat of thick black mascara. Marta fills in her brows, which tend to be sparse, with a dark brown liner and sets them with a clear brow gel to keep them in place all day.

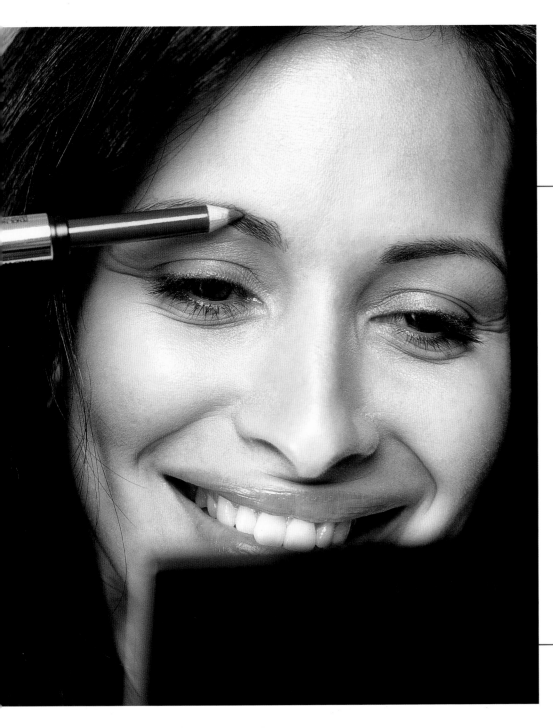

Purple and Lilac at Night:

For night Marta intensifies her sexy almond-shaped eyes with extra color. She applies a strong shade of violet in the crease of her eyelid and then a sharp line of liquid eyeliner in basic black to add a little drama into the night. She finishes off the eyes with several coats of mascara. Again, just a touch of berry-colored cream blush is all she needs on her cheeks, but this time she combines it with a sheer shimmer highlighter under the eyes. Marta uses a berry-colored lip gloss to enhance her smile. On her slender hands she applies a sheer nude nail enamel, but on the toes a darker berry shade.

Get This Look: **PERFECT ARCHES**

Often neglected, the eyebrows are actually probably the single most important and easily changeable feature on the face. Groomed brows can add an instant lift and open up the upper face for a lighter, younger look. However, hair removal anywhere, and especially on the face, requires precaution and precision. Most experts advise seeing a professional the first time you trim your eyebrows, and from then onward you can follow the shape that they have outlined.

STEP BY STEP: TWEEZING BROWS

Take care when grasping the hair; careless tugging may catch skin and cause infections. Remove hairs only from underneath the brow, as plucking from above may cause hairs to grow back in the wrong direction. Cleanse the area before you begin; you may find that warm water opens up the pores, allowing the hairs to pull out more easily.

1 To find your perfect shape, take a pencil and line it up alongside the nose, standing it straight up. This is where the brow should begin.

2 Now pivot the pencil across the eye to the middle of the brow (directly above the iris of the eye). This point should be the highest point on your eyebrow—where your brows should arch.

3 Continue to pivot the pencil outward to a 45-degree angle from the side of your nose toward the top of the ear; this is the point where your brow should end.

4 First apply warm water to open up the pores, and then comb the brows into place to find strays.

5 Slide the tweezers underneath the hair, clasp it at the root, and squeeze the hair out in the same direction as it grows, using quick, sharp movements.

6 Remove one hair at a time, making the arch the highest point on the face and pausing to assess the overall shape of the brow before you continue.

7 If desired, brush the hairs straight up with a brow brush. Using small cosmetic scissors, trim any hairs that stray above the upper line of the brow.

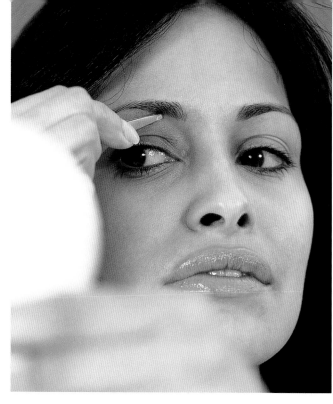

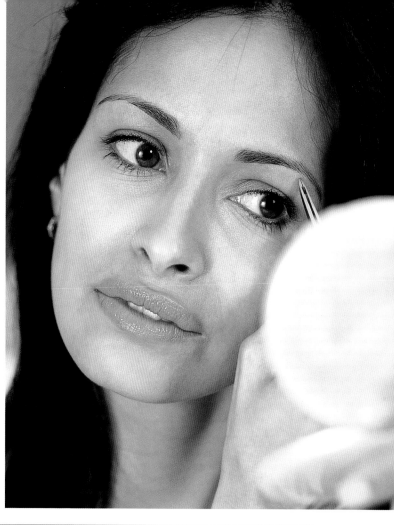

EYEBROW SHAPING GLOSSARY:

Slanted Tweezers: Slanted tweezers are somewhat easier to position than pointed tweezers and are good for ingrown hairs.

Pointed Tweezers: This type of tweezers is better for stubborn and shorter hairs, but can be awkward to use.

Wax: Beeswax is the most common type used for depilating this area of the face, but should be applied in only very small areas at a time.

TIPS

- Never shape eyebrows yourself for the first time right before an important function.
- Never take too much hair off the top of eyebrows. The upper edge of brows should be left in their natural shape. If they are very unstructured, remove hair sparingly.
- When waxing, cover very small areas at a time.
- Use an astringent after waxing or tweezing to cool down redness and close the pores. There are also ointments specially designed for reducing irritation from waxing.
- For extra help in shaping your brows, try drawing a guideline using an eye pencil before you start plucking.

Get This Look: PERFECT COLOR

Whether you are using a pencil, powder, or gel to add definition to your brows, never use the color to create shape or outline past the brow line. Anything other than your natural shape will make you look artificial. Although trends in eyebrows change frequently—one day it is dark, full eyebrows and the next it is pencil-thin brows—take your clue from your own face. Large features and big eyes need a frame, whereas delicate looks will probably look best with a subdued brow treatment. As far as color goes, your brows should be the shade of your hair, or one shade lighter. Brows that are too dark can make you look angry or ferocious; conversely, if you have nonexistent brows, you will need to define them to give your face some impact.

STEP BY STEP: DEFINED BROWS

Powder gives a softer and prettier finish than a pencil, but pencils often have a brush at one end, so you can fill in sparse areas and use the brush to blend. A brow gel is a quick choice and has a dual function—it grooms the brows into place, helping them stay put, and also adds color, helping to define them. This method uses a pencil, then a powder for extra staying power. Another option is a translucent brow-setting wax that works much like a gel.

BROW COLOR GLOSSARY:

Brow Gel: Available clear or tinted and usually found in the form of a wand with a brush, brow gel keeps wayward hairs from going awry for hours at a time.
Pencil: Eyebrow pencil is perfect for filling in gaps in the eyebrows and provides a soft, natural look.
Powder: Used with a stiff brush, powder is usually available in duo colors, so you can blend them to get the color you need.
Dye: This treatment is best achieved by a professional.

1 Using a pencil, fill in any gaps in your eyebrows with light, feathery strokes. Work from the thickest end at the nose toward the outer end in the direction of hair growth.

2 Blend a matching powder onto the brows with a brow brush, again working in the direction of hair growth. Skip this step if you have light brows and don't want too much color.

3 Brush through the brows to help blend in the pencil, working outward and upward. If desired, finish with a gel to set the brow color in place and tame any straggly hairs.

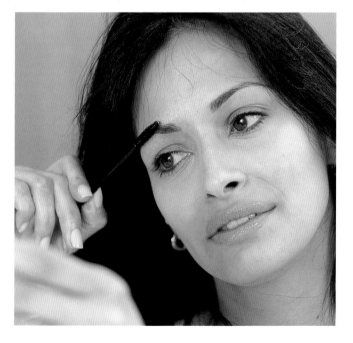

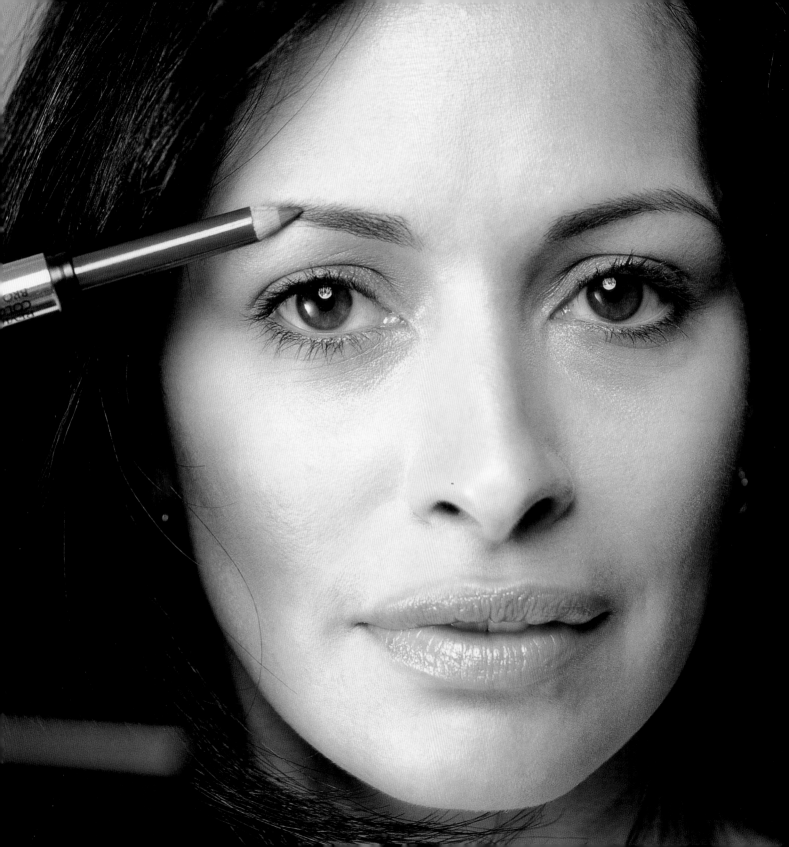

Purples and Lilacs for Everyone

Purples can travel from soft to sexy and from day to evening, depending on the shades and the application. They are also among the few colors that work well on all skin types and in all areas of the face, from a plum eyeshadow to a sexy dusty-lilac blush, to a deep wine shade on the lips.

Blondes

Soft, pale eyeshadow colors, like dusty lilac and muted violet, look beautiful on blondes.

Brunettes

A PLUM LIPSTICK LOOKS GREAT WHEN APPLIED WITH A FINGER FOR A STAIN EFFECT, BUT ALSO MAKES A SEXY NIGHTTIME LOOK WHEN APPLIED STRAIGHT FROM THE STICK TO THE LIP.

Asian Skin

Those with yellow undertones should wear purple with more blue hues. Violets on the cheeks work well, too.

Redheads

Redheads should wear lilacs with red undertones, like a raspberry lip gloss or plum cream blush.

Dark Skin

Darker skin tones can pull off intense berry shades well. Brown eyes look dramatic in saturated purples with magenta undertones.

Olive Skin

YELLOW IS THE COMPLEMENTARY COLOR TO PURPLE, SO THOSE WITH SALLOW UNDERTONES LOOK GOOD IN SHADES OF LILAC. TRY CONTOURING DARK PURPLE EYESHADOWS IN THE CREASE OF LIDS AND HIGHLIGHTING WITH LIGHTER PURPLES ON THE BROWBONE.

rose

rosa

rose

pink

rosa

rose

Our Associations with Color

Pink is undeniably the most conventionally feminine color in the spectrum. Once associated with baby girls and cutesy ruffles, pink has taken on a role representing the power of the feminine mystique, evoking a sexiness that's both womanly and even sophisticated. From barely-there blush to a rogue fuchsia or a naughty-but-nice petal, pink is shedding its childish image. No longer weak and insipid, it is now unequivocally representative of girl power; no wonder the campaign for breast-care awareness has taken pink for the color of its ribbon. Whichever image springs to mind when you think pink—rosebuds and floral bouquets, hot-pink Schiaparelli scarves, pink satin lingerie—you have to admit this over-the-top color keeps cropping up as a favorite everywhere.

Rosewater and rose oil

- Rosewater and rose oils were first used in tenth-century Persia, and today most of the rose oils are still produced in that region of the world. A large quantity of petals is needed to produce a very small amount of oil, which makes the oil extremely costly. Thankfully, only a small amount is needed in therapeutic and cosmetic preparations.
- With authentic rose oil, a little goes a long way. It is not used in its concentrated state, but rather in a carrier oil, such as almond, jojoba, or grapeseed. Whether mixed into a massage or facial oil, a nourishing skin cream, or a bath elixir, or burned in a vaporizer, the fragrance is one of the best-loved in the world.
- Generally rose oil and rosewater (a by-product of distillation) are used topically rather than internally. However, with aromatherapy, the rose essence may be inhaled, via steam or diffusion methods.
- Although used in extensive and varied ways, rosewater is most often employed in skincare preparations for its soothing and antiseptic qualities. It makes a suitable cleansing tonic for all skin types, but it is especially valuable for dry, sensitive, or aging skins. Because it has an astringent effect on the capillaries just below the skin surface, it can diminish the redness caused by enlarged capillaries. Certainly rosewater is a less expensive alternative to a commercial toner.

"I adore that pink. It is the navy blue of India."

DIANA VREELAND

If You Like Pink:

Because pink is a softened red, it is associated with sweetness and purity. Many people connect it with romance, delicacy, refinement, good temper, and tenderness. Those who love pink are interested in the world around them, and want to live in a peaceful, harmonious place. Violence in any form can upset them. At one time, pink was thought exclusively feminine, but more men are comfortable with pink now because exhibiting sensitive, so-called "feminine" traits is no longer considered unmasculine. In fact, salmon shades are considered quite stylish on men. If you love pink, you're in luck in the beauty department. Virtually every area, from nails and eyes to cheeks and lips, can take on a pink shade of one kind or another.

If You Dislike Pink:

Soft, medium tints do not evoke much emotion, and as pink is red with the passion removed, people who dislike pink tend to seek out more adventure and excitement in life than do pink-lovers. Being more worldly, they do not connect to the naïveté and innocence that pink symbolizes.

ColorSense

A NATURAL CHOICE FOR LIPS AND CHEEKS, PINK HAS LONG BEEN USED TO ENHANCE THE FACE OR MAKE THE SMILE A TOUCH MORE ALLURING, BUT IT IS ALSO A GREAT SHADE TO MIX WITH OTHERS. A CREAMY OR GLOSSY PALE PINK CAN BE BLENDED WITH ALMOST ANY COLOR—EARTHY BROWNS, VIBRANT GREENS, DUSTY VIOLETS, OR SEA BLUES—RENDERING DEEP SHADES MORE NATURAL AND BRIGHT HUES MORE SUBTLE. THE IDEAL COLOR TO BRING SKIN TO LIFE, PINK CAN PERK UP THE PASTIEST OF COMPLEXIONS.

Create a sophisticated, modern look by combining medium-bright pinks with a nude makeup palette. Alternatively, pair next-to-nude pink lips and cheeks with a smoky gray eyeshadow to create a mysterious but ultimately feminine look.

Pastel pinks add the right hint of blush to pale skins, while darker skins look best in brighter, hotter pinks. If your skin tans in the summer, limit your use of pink to cotton candy or bubblegum shades and use them on the toes (a blush-colored manicure is best kept for when the temperature turns cooler).

Get the glow by using a pink-toned highlighter on the browbone, temples, or cheekbones. While pink is not traditionally recommended for redheads, a dusting of powdery pink shimmer can look lovely on fair skin, especially when used on the apples of the cheeks. A shimmering pink eye, lip, and cheek gloss catches the glow of skin and draws attention to features without any artifice.

Dark pink, such as cranberry, looks romantic when used in the creases of eyelids and repeated on the cheeks, but avoid teaming purplish pinks with true reds, which will clash.

Pink peonies are a symbol of prosperity, because at one time only wealthy Japanese could afford to have them in their gardens.

inspirations

Infuse a shot of femininity into any look with a pink blush and lipstick. Sometimes the best looks are ones that conflict slightly, such as a menswear-inspired pantsuit softened with a carnation pink shirt and rose-colored makeup.

Play up girlish innocence by wearing pink; it might be the perfect cover for a less-than-innocent strategy. The passive, energy-zapping qualities of pink can be used to disarm an opponent, or to enchant the unwitting.

Pink makes you feel pretty. It just might depend on which shade does the trick, though. Magenta and fuchsia work best after dark and on women with strong coloring, while rather pale beauties can freshen up with clear watermelon, delicate rose, or sugar pink.

Fresh petal and blossom pinks are just the colors to herald in spring and highlight your assets. Concentrate the color on the lips and cheeks for a natural, flushed look.

COLOR ANALYSIS

A standard in cosmetology practice, color analysis uses the idea that your skin tone, and to a lesser extent your hair and eye color, can dictate which cosmetic colors work best for you. Whereas this is often useful to know, it by no means indicates that an entire range of color is off-limits to you. Here we give you a general overview of color categories, divided into warm and cool palettes, though many professionals use spring, summer, autumn, and winter categories, and break down the divisions within them. Every individual has their own genetic blueprint, however, and many people cross categories—you can be a warm and cool blonde, redhead, or brunette. You may have a pinky complexion and fiery red hair or golden skin and warm brown locks streaked in copper. Although matching your foundation to your skin tone is absolutely necessary, you can experiment with color on the lips, eyes, cheeks, and nails. Color is about personality as much as the physical attributes you were born with, and you can vary your coloring as often, or whenever, you like.

Warm Palette

The colors in a warm palette consist of yellow-based shades, such as yellow-greens and yellow-reds, which include golds, coppers, oranges, orange-reds, browns, corals, peachy pinks, browny pinks, and gold-pinks. Traditionally these colors are most suitable for skins with a yellow undertone or fair skin with golden freckles; turquoise to blue-green, hazel, green, or brown eyes; and hair in dark brown shades with gold or red highlights, honey blonde, warm brown, or strawberry to coppery reds.

Cool Palette

Colors with blue-based undertones, such as blue-green or blue-red, which includes plums, rose-pinks, berries, turquoises, periwinkle, and royal blue, make up the cool palette. These colors traditionally suit pink complexions and skins with a blue undertone; light to dark blue, hazel, green or brown eyes; and hair that is light to dark blonde, light to dark brown or black. They are also the tones that most often suit older women, those with gray hair, and those with strongly-contrasting fair skin and raven locks.

Seasonal Pinks

Updating your color for the season is often a natural event; perhaps you graduate from fuchsia to plum lip color as the winter approaches, or you use a tinted moisturizer rather than a foundation as the days get warmer. Summer makeup definitely does not look right in winter; your clothes change, your tan fades, you spend more time indoors than out—all of which contribute to a new look for a new season.

Summer

During hot summer months, take your clue from the weather. On humid days you will want to keep as cool as possible, whereas arid days may make you want to turn up the volume. Choose cooling raspberry and rose, or warm pinky golds, hot pinks, and fuchsia.

Winter

With winter, you can add drama with saturated and darker hues. Foundation coverage will probably increase, so it is wise to invest in a good formula, especially one for drier skins to counteract central heating and harsh weather. Wintry pinks are deep and rich berries, wines, burgundies, and magentas.

Fall

Take inspiration from the rich array of colors that abound during this beautiful time of the year. Cool skin tones look good in rusty pinks and cranberry, whereas warmer skins can use yellower pinks like salmon and pimento.

Spring

Clear, bright hues and flower colors herald this time of the year. Cool tones look good in watermelon and carnation, while rose and strawberry work for warmer complexions.

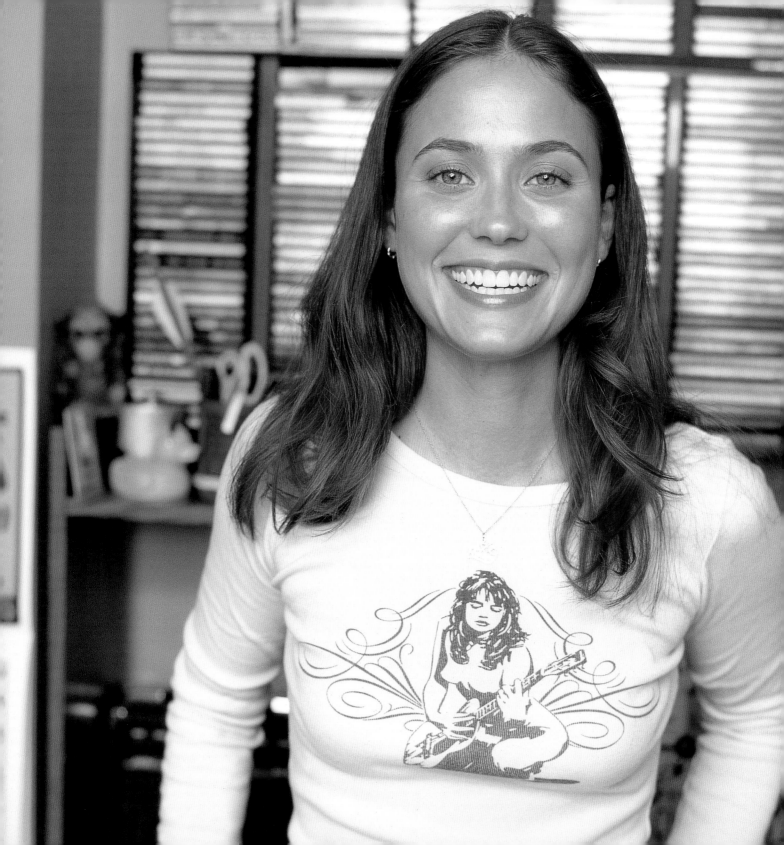

"Pink lipstick just makes me want to pucker."

KELLY SEBASTIAN

IN AN APARTMENT crammed with pictures and paraphernalia from CDs and videos to family portraits from the 1970s, 23-year-old Kelly Sebastian, a freelance film producer and media librarian, has an infectious smile and bubbly personality. Her natural confidence is one of her special traits, and has been in evidence since her school days. "I never felt the pressure everyone talks about during adolescence. I was interested in playing sports and shooting hoops with the boys."

Among the many "hats" Kelly wears, she occasionally models and performs on her own public-access TV show. Kelly says she feels most beautiful when she's having her picture taken: "I wear makeup that I love but wouldn't necessarily wear normally, like red lipstick." Kelly's first foray into beauty was starting to

> **" A friend told me curling my lashes would open up my eyes. She was right—I still do it every day."**

curl her eyelashes. Her eyes, a striking combination of blue, green, and gray, change depending on what she's wearing. Her changeable eyes are, for her, symbolic of her widely varied interests. From volunteering on political and social causes to creating experimental films and working on her TV show, Kelly's zest for life is apparent. When asked where she possibly finds the time for all her activities, Kelly shrugs it off as inevitable: "I could never just sit around, except on the occasional Sunday," she says, laughing. Her enthusiasm is inspiring as she tells people about her music and songwriting, her photography, and the way she organizes live performances. As Kelly changes clothes and makeup for the photo shoot, it's apparent how comfortable and confident she is with herself—and why shouldn't she be? How many other people can claim as many varied accomplishments by the age of 23?

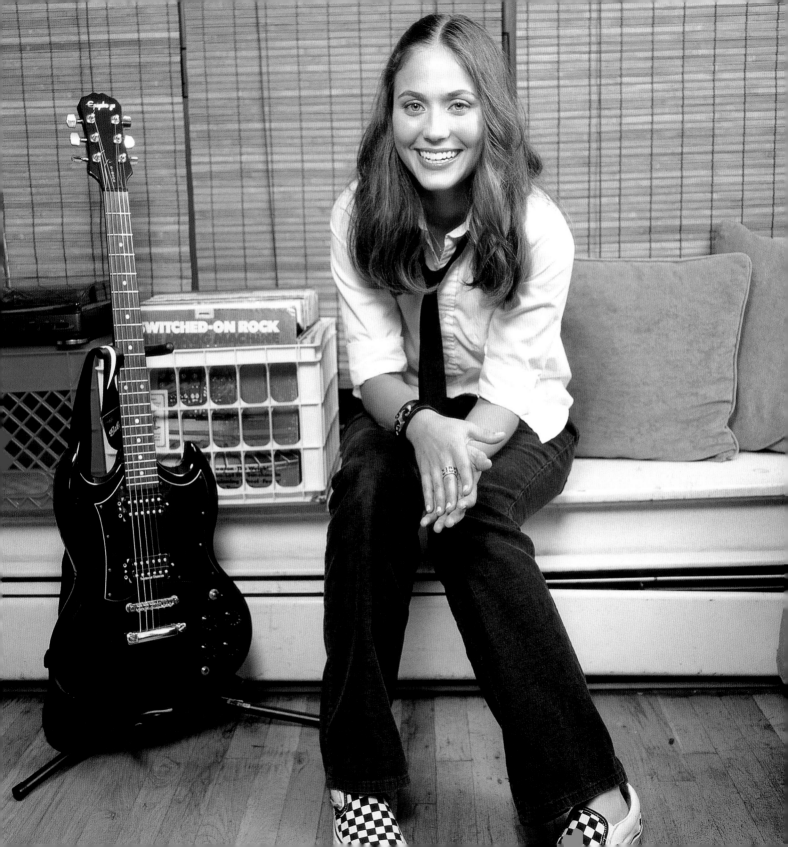

Pink for Day:

For Kelly's daytime look, makeup artist Molly Stern matches a shimmery tinted concealer to Kelly's perfectly clear complexion. Then Kelly applies a light moisturizing concealer, dabbing it gently under her eyes, and a touch of shimmery foundation on the cheekbones. Kelly's gorgeous light brown hair and chameleon blue-green eyes don't need any further enhancement. A little dewy cream blush on her cheeks and a perfect pink pout are all it takes for Kelly to be ready to go.

"Pinks hold a fresh, youthful appeal that works on everyone."

makeup artist **MOLLY STERN**

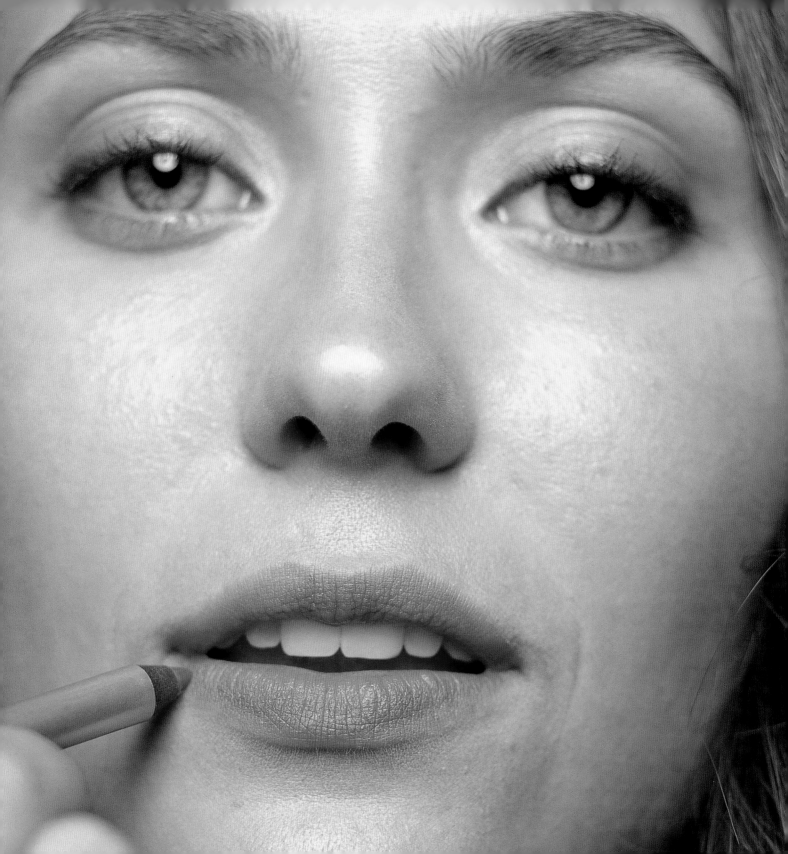

Pink at Night:

For nighttime, Kelly uses neutral-colored cream eyeshadows with just the right hint of shimmer to enhance, but not overpower, her eyes. She applies a pale pink liner on her lips, covering the entire lip area, and topping it off with a shimmery gloss applied with her finger.

Get This Look: **GOOD FOUNDATION**

When skin is looking less than fresh, whether due to an untimely breakout or a poor night's sleep, it's tempting to try to cover up the flaws. But overzealous attempts at foundation only look worse, and you're not hiding anything by loading up on cakelike makeup. However, even the fullest coverage can provide a natural-looking finish when applied properly. Foundation can do everything from adding the right hint of shine to dull skin and providing a matte finish for oily complexions to simply covering up blemishes or under-eye circles. Whether you prefer a sheer veneer of concealer or a full face of foundation, learn the tricks of the trade. And remember: few people were born with perfect skin.

STEP BY STEP: LIGHT COVERAGE

Sheer coverage is ideal—your skin looks natural while its tone is evened out subtly. Choose from one of the options on the right for a result that suits you.

1 Begin with a clean, moisturized face. Let the skin begin to absorb the moisturizer before you apply the next product.

2 Concealer should be the first makeup that you apply. Start on the outer corners of the eyes and dab inward. Continue to dab concealer where necessary for coverage of imperfections.

3 Next, apply a sheer liquid foundation for an overall light coverage. For the most natural look, you can omit this step.

4 To finish off the base coverage, gently dust over a loose translucent powder using a soft makeup brush.

FOUNDATION GLOSSARY

Concealer: Usually found in the form of a wand, concealer is an on-the-spot treatment for small problem areas.

Tinted Moisturizer: One of the staples of any smart beauty routine, moisturizer can also be tinted to match your skin tone, therefore eliminating one step in the process. Helpful Hint: Tinted moisturizer is perfect for daytime or for a natural look but doesn't have the concealing power of a true foundation.

Pressed Powder: Traditionally found in a compact, pressed powder is good for those who tend toward shiny skin or for a quick touch-up.

Loose Powder: This thick powder is applied with an oversized brush and achieves a matte look.

Light-Reflecting Foundation: Brightens skin and provides just a hint of color without the look and feel of traditional foundation.

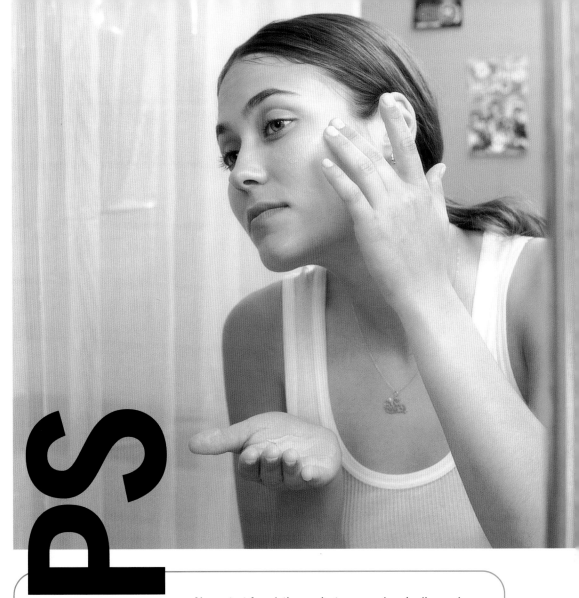

TIPS

- Always test foundation against your neck or jawline and examine under a good light to test for color correctness.
- Blending is the most important part of foundation application. It can be done with fingers or a makeup sponge.
- Use color-correcting foundation to mask redness in skin.
- Foundation should be the most opaque in the T-zone and gradually become more sheer as it approaches the chin.

STEP BY STEP: FULL COVERAGE

Full-coverage foundation will provide a flawless finish. It is also best for special occasions, such as your wedding day or for having your photograph taken. The correct application will help you create a perfect-looking base—just follow the instructions below for an effective finish.

1 Begin with a clean, moisturized face; let the skin absorb the moisturizer before you apply the first product.

2 Starting on the outer corners of your eyes and working inward, dab concealer under the eyes and toward the center of the face. Now dab concealer anywhere else it is necessary to cover imperfections or blemishes.

3 Choose a liquid or cream foundation for opaque coverage. Lightly load a clean makeup sponge with the foundation, and gently swipe over the face, blending from the center of the face outward. Because you should still focus on areas that need coverage most, apply a second layer to these areas.

4 After blending well, apply the rest of your makeup. Finish with pressed or loose powder to set. Touch-ups will be necessary throughout the day.

TIPS

- Let foundation set for a few minutes before applying any color on top.
- If you have a tendency toward oily skin, finish off any moisturizer or concealer with a matte or pressed powder.
- After applying loose powder, dust off the excess.

neutral

neutral

natu

neutral

neutro

natura

colore neu

Asian Skin

Because of their yellow undertones, Asian women should use pinks that contain blue. Peachy pinks can look sallow on Asian skin.

Redheads

It used to be a steadfast rule that redheads couldn't use pink makeup, but not so anymore. "Redheads can look lovely in a sheer veneer of very pale pink blush or a dusting of pink shadow on the eyes," observes Molly Stern, "but should stick to paler, more transparent pinks."

Dark Skin

Black women look just as great with glossy, pale pink lips as they do when they wear an orange sunset pink.

Olive Skin

THOSE WITH OLIVE SKIN SHOULD USE ICY AND FROSTED SHADES OF PINK RATHER THAN REDDISH PINKS.

Pinks for Everyone

Pink is among the most feminine colors in the spectrum, and it's often associated with youth, softness, and flirtation. From sophisticated salmon to in-your-face fuchsia, the pink palette offers something for everyone.

Blondes

Blondes can experiment with pale pinks with blue undertones, and also try a pink all-over shimmer for extra radiance. Ash blondes look best in cooler pinks, whereas golden blondes should choose redder pinks.

Brunettes

BRUNETTES USUALLY HAVE A COLORING THAT ALLOWS THEM TO EXPERIMENT WITH A WIDE RANGE OF PINKS, THOUGH PASTELS ARE PROBABLY NOT THE BEST.

"Always moisturize first; moisturizer is truly the foundation of any beauty routine."

MOLLY STERN

neutral
neutral
natural
neutral
color
color
al
neutro
neutro
neutro
neutral
neutro
neutr

Our Associations with Color

Although Mother Earth's natural browns and beiges are associated with substance and stability, they may not seem the most romantic or evocative of colors. They are, however, responsible for giving subtlety and depth to other colors. Without them we could have no nuances. In fact, neutrals encompass a much fuller range than browns, and include all variations of white and black.

Skincare Glossary

Here are some useful terms to help you get to grips with your skincare. Developing good habits not only will leave your skin looking better and feeling healthier, but will provide a better base for makeup.

• **T-zone:** The forehead and the bridge of the nose.

• **Exfoliant:** A facial scrub that uses either organic or man-made particles to remove dead surface cells from the skin, helping to reveal a more radiant skin. Exfoliating improves circulation and a lackluster complexion.

• **AHA:** Alphahydroxy acids break down the intercellular "glue" that binds dead skin cells to the face and body. A type of exfoliant, AHA products buff away dead skin cells. AHAs can make skin more sensitive to light, so use extra sun protection in conjunction with the product.

• **Antioxidants:** Found in vitamins, such as vitamins E and C, and beta-carotene, antioxidants protect body cells from the damaging effects of oxidation and rid the skin and body of free radicals, which accelerate the aging process.

• **SPF,** standing for "sun protection factor," is a measure of how long you can stay exposed to the sun without burning. When choosing an SPF (which ranges from 2 to 60), take into account your skin type, the strength of the sunlight, the type of sunscreen you use (gel, cream, lotion, or oil), and the amount you apply. You should wear no less than SPF15.

• **Hypoallergenic:** These allergen-free products are suitable for sensitive, temperamental skin.

Face Masks

Playing in the mud is not an activity you have to outgrow. For centuries mud has been used in beauty treatments to improve the appearance and texture of skin. Particularly beneficial for those who suffer from eczema, psoriasis, and acne, it is able to draw out impurities because any excess sebum, along with dead skin cells, attach easily to mud particles. In addition, some types of mud used in beauty preparations—in particular, Dead Sea mud—have a rich mineral content, which nourishes all skin types. These days you can find mud masks designed for the face, body, and even the hair and scalp. However, most experts recommend using mud masks only once a week unless your skin is very oily, as overuse tends to dry the skin.

If You Like Neutrals, such as Brown and Beige: Those

with a preference for brown have a steady, reliable character with a keen sense of duty. They are down-to-earth with a subtle sense of humor. Brown-lovers appreciate comfort, simplicity, quality, harmony, hearth, and home. They are loyal friends, are firm but understanding, have strong views, and may be intolerant of others who talk or act too quickly. They strive to be good money managers. Beige-lovers have many of the same characteristics, though they are probably less intense. They are warm, well-adjusted, practical, neutral in most situations, and appreciate quality.

If You Dislike Neutrals, such as Brown and Beige:

These individuals probably fantasize a lot, because novelty excites them and routine drives them crazy. They are often witty, impetuous, and generous. Homespun people bore them; they like people who are bright and outgoing. Those who dislike beige are less frenetic and impetuous, but have many of the same characteristics. To them, beige represents a beige existence—boring and tiresome.

ColorSense

BROWNS AND BEIGES ARE BREAKING OUT OF THE ORDINARY. ALTHOUGH THE STAPLE FIXTURE IN ALL BEAUTY BAGS AND A NECESSITY FOR EVEN THE MOST EARNEST GLAMOUR GIRL, THESE COLORS DO NOT MEAN BORING OR MIDDLE-OF-THE-ROAD. THEY ARE THE TOOLS TO CREATING A FLAWLESS-LOOKING FINISH, BUT ARE ALSO IMMENSELY VERSATILE; THEY CAN BE BLENDED AND LAYERED WITH OTHER COLORS AND MADE RICH AND VIBRANT WITH GOLD ACCENTS.

Take advantage of the fact that neutrals go with everything, and wear beiges, browns, and taupes along with shocking pink lipstick, sage green eyeshadow, or electric blue mascara. There is no need to get caught in a bland neutrals routine—every now and then experiment and break free from your basic daily neutral palette.

Blend colors well and apply in a well-lit room. Though this is true for all cosmetics, makeup that is close to your own skin tone can be more difficult to blend in. The good thing is that all neutrals work together, so you can concentrate on layering different textures and finishes.

Always use a neutral-colored lip liner. If you use a dark liner it may stain the lip, and when your lipstick wears off you'll be left with just a ring. Nude lips also look great with smoky eyes, or try beiges and browns with pink undertones, such as a tawny brown for the cheeks or a rosy beige for the lips. Steer clear of matte browns, though, because the color will seem flat and caked—not a kissable look in any case.

A nude manicure is perfectly sexy and perfectly professional. You can either buff the nails and apply a clear coat of polish or go for creams, camels, or bronzy browns.

Creamy colors evoke warmth and a comforting feeling.

inspirations

Browns are earthy and cozy, so if you want to heat up a snowy night, experiment with deep chocolate brown and gold-flecked mahogany shades.

Neutrals help you appear cool, calm, and in control. A taupe pantsuit works for occasions as diverse as dinner with your loved-one's parents or for crisis meetings at work, and the color may help placate others' feelings and keep you out of any crossfire.

Basic and dependable, neutral makeup will never let you down. These colors aren't all about matte browns and beiges; they also include gorgeous earthy hues and tints, from terracotta, almond, and burnt sienna to mocha, marshmallow, and tawny rose.

Like to play it safe? Choose a good palette of neutrals for your first makeup purchase. Once you have the basics, you can extend the collection with colors and metallics to add richness and shine.

PREPARING FOR MAKEUP

Makeup is all about enhancing your natural attributes, but what if your natural attributes need some work? Laying the groundwork in terms of skin and body care is the first, but often neglected, step toward a truly stunning finished look, and it is easily achieved with a few simple steps. As any professional will tell you, starting with clean, moisturized skin is the most important prerequisite to applying makeup. If you get your skin looking its best, glowing and bright with an even tone, makeup will work as it is supposed to—to reveal the real you. Besides, foundation, lip color, and shadow all will adhere better, and you won't run the risk of looking like you use makeup as a mask to hide behind. The basic rules of good skincare can be adapted whether your skin is oily, dry, sensitive, or a combination, at whatever age you happen to be.

- **Know your skin type and choose appropriate products to maintain it.**
- **Keep to a daily morning and evening routine that is realistic for your lifestyle.**
- **Always remove your makeup at the end of the day.**
- **Recognize your trouble spots, whether it is the occasional outbreak, dry patches, broken capillaries, or a shiny T-zone, and choose remedies to combat recurring problems.**
- **If your skin reacts badly to certain products, climates, pollution, foods, or alcohol, take steps to eliminate or reduce their impact.**

Cleansing

Choose a cleanser formulated for your skin type; soap-free cleansers are usually good for sensitive skin, creamy emollient-based types for drier skins, and soap products often work best for oilier skin. Read labels carefully before buying, and if a product causes a bad reaction, immediately discontinue its use. Make sure your product is suitable for thoroughly cleansing your skin as well as simply removing surface dirt. Get into the habit of cleansing your face morning and night, and you will be protecting against blemishes and outbreaks and keeping the skin aglow.

Exfoliating

Loofahs, buffs, and similar tools are great for the body and feet, but too abrasive for the face. Exfoliators are labeled for the body or the face, so never use a body version on the face. You may also find that natural-abrasive facial scrubs are too harsh; if this is the case, use a synthetic-based version containing AHAs, or one labeled as gentle. Exfoliating sloughs away the outer dead skin cells, leaving a brighter appearance. It can reduce flakiness in dry skins and clear impurities from oily skin, but should be used only as a once- or twice-weekly treatment on the face.

Toners and Astringents

Essentially used to remove excess oil and residue from the skin, these can feel refreshing; however, they can also strip the skin. If you like these products, try a gentle one that does not contain alcohol or witch hazel; alternatively, use rosewater.

Moisturizers

Applied after cleansing, moisturizers nourish skin and plump it up in preparation for makeup. Although a mainstay of the skincare routine, moisturizer does not need to be loaded on. Skincare technology ensures that more is not necessarily better. A light application is all that is needed, and if you have combination or oily skin, you may prefer to use it only in those areas that feel tighter or drier after cleansing. Be aware, too, that seasonal changes will affect your need for moisturizer, and you may find it is not necessary to use it at all in humid summer months.

SPF Protection

Moisturizers, foundations, concealers, and lip colors often contain added SPF protection, but to protect against sun damage fully, apply a thin layer of sunscreen, especially during the summer when the sun is at its strongest. Many women choose to use a sunscreen year-round as protection against wrinkles, age spots, and premature aging.

Special Treatments

Facials and masks are a luxurious occasional treat, and they can perform different functions, from exfoliating to moisturizing, cleansing, or skin-softening. Choose one for your skin type and the purpose you want. If a mask stings, remove it at once. Avoid clay-based masks on sensitive or dry skin or moisturizing ones on oily skin.

Hand and Foot Care

Keeping to a regular manicure and pedicure routine will ensure that your nails look fantastic even when bare of color. Take the time to apply hand and foot cream and cuticle oil, smooth away rough patches, treat calluses and ingrown nails, push back cuticles, and file or clip nails for a polished look.

"We know so much more about skincare and health now. It's negligent not to pay attention."

DIANE TOWNSEND

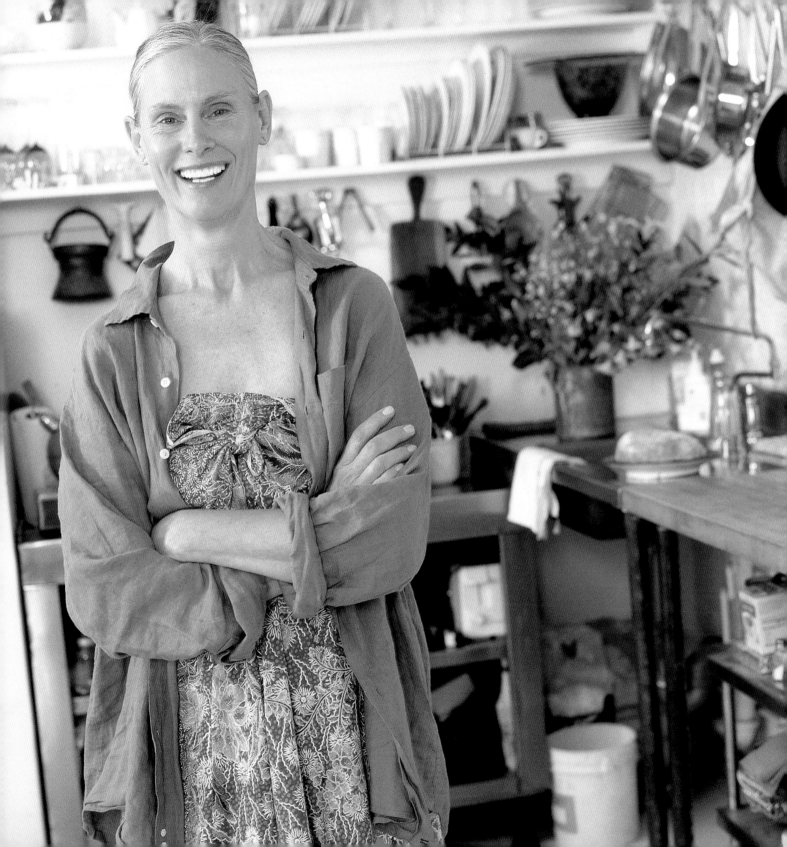

WHEN SPEAKING TO 56-YEAR-OLD DIANE TOWNSEND, it's hard not to be distracted by the intensely positive, wise energy that radiates from her calm presence; she seems to glow from the inside out. The painter creates her own pastels from scratch in her bright SoHo loft studio, which is flooded with light during the day. Diane shares her loft with her husband, Judah Catalan, also an artist. His pictures, too, fill the sun-soaked loft they both work in, along with bowls of vibrant, fresh vegetables in beautifully painted ceramic bowls. Diane, who began a strictly vegetarian diet in the 1980s, says all good things in life begin with basic health improvement but admits good genes don't hurt—both of her parents had great skin throughout their lives. During her twenties she spent time in the sun, but she has been covering up ever since. "We know so much more about skincare and health now than we did then. It's negligent not to pay attention."

> **"I was in a ballroom dance recital in grade school and wore bright lipstick and I loved it."**

Diane reflects on memories of herself raiding her mother's array of makeup. "I was in a ballroom dance recital in grade school and wore bright lipstick, and I loved it. From there into high school I experimented with offbeat color cosmetics: tons of eyeliner, shadow, white lipstick, even green fingernails." She throws her head back and laughs. As is so common, Diane had a hard time at first with the feature that she now loves best about herself. "I hated being tall in junior high school. I didn't carry it well—I felt very awkward, I was so much bigger than the boys were. But in the end it's what made me question stereotypes. It made me defiant."

Diane Townsend with her husband Judah Catalan ▶

Neutrals for Day:

For days in her natural-light studio, Diane's natural radiant skin glows on its own. She dabs a spare amount of concealer under her eyes and a dewy, sheer layer of foundation in the T-zone in decreasing amounts as it works down her face. On her lips she uses a spicy mauve lip liner and a creamy nude lipstick. Her cream blush is just a shade darker than her natural skin tone to give her an added glow. On her eyes she applies a buff-colored wet/dry shadow for just a hint of color, topped off by a lustrous thick coat of black mascara. She maintains a top-to-toe natural look with a classic nude manicure.

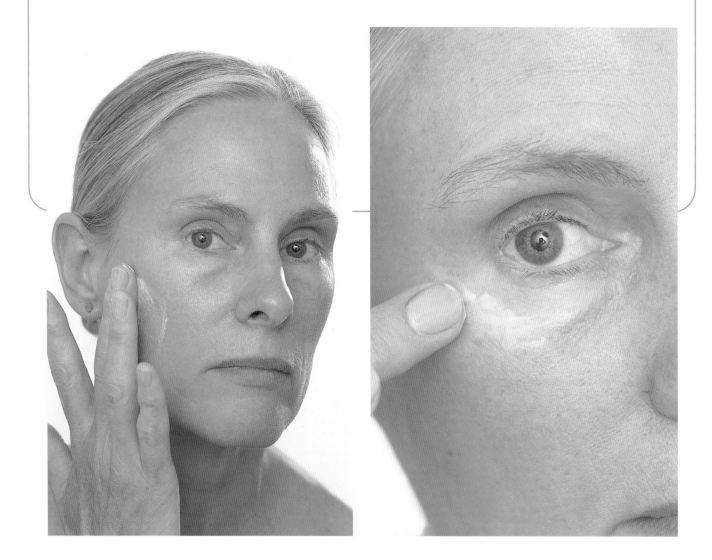

Neutrals at Night:

For nights, Diane adds slightly more color to the apples of her cheeks on top of her regular, sparsely applied, foundation. On her lips she uses a cocoa-colored lip liner and fills in her entire lips to create a matte effect. Diane applies a deep wine shade on her lips that complements her bright blue eyes. Again, keeping a nude manicure, she accentuates her eyes with two coats of mascara but lets her deep lip shade be the only bold makeup statement on her face.

Get This Look: GLOWING SKIN

A supple, brightened complexion is the hands-down number-one desire of every woman. Not a trend but a lifestyle, gorgeous skin is the common denominator of all the great beauties through every era. While makeup can help the process along, good skin starts from the inside out and requires all the elements of good health: a well-balanced diet with lots of vegetables, a proper amount of rest each night, lots of water, vitamins, and nutrients, and something to rid yourself of the inevitable daily stress (the stress factor negatively affects the look of skin). Actually our skin can be thought of as a daily messenger—the saying "It's written all over her face" is quite truthful. Personal elements such as heredity, age, and skin type obviously play large parts in how to care for skin, but there are some steadfast rules for everyone to follow.

STEP BY STEP: MORNING SKINCARE

Making a clean, well-moisturized face the first priority for the new day will get your skin off to the best start. Select a cleanser suitable for your skin type (see pages 192–3) and in a format you will use—some people prefer creams or lotions, whereas others like soap-based products.

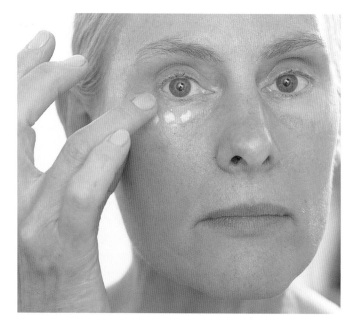

1 When using a lotion, cream, or liquid, apply the cleanser in a circular motion onto a wet face. Using gentle, circular motions will increase circulation and get blood flowing.

2 Rinse well, then gently blot the face with a towel; or remove cleanser with cotton balls. Be careful not to rub vigorously or pull and tug, especially in the eye area.

3 Exfoliate twice a week, using the same method as for a regular cleanser (see steps 1–2). Now to freshen the skin, apply a toner appropriate to your skin type with a cotton ball.

4 Use an eye cream to reduce puffiness and dark circles. Apply in dots below the eye, and pat in gently with the ring finger from the outer corner of the eye inward.

5 Moisturize the entire facial area. Apply in an upward direction from the base of the neck. Finish with an SPF15 or higher sunscreen, depending on skin type and environment.

STEP BY STEP: EVENING SKINCARE

The most important consideration with evening skincare is to remove all traces of makeup and to apply a nighttime moisturizer to help skin regenerate and repair during sleep.

1 If you are using a cream makeup remover, apply a thin layer all over the face, gently massaging it in. If you are using a liquid remover, saturate a cotton ball with the formula.

2 Remove makeup from the eyes first with a cotton ball, working from the outside inward. Now wipe or rinse off the remaining remover from the rest of the face.

3 Cleanse using the same process as for the morning (see steps 1–2, opposite).

4 Apply a toner or astringent with a cotton ball to close the pores and remove residue from the skin's surface.

5 Apply an enriched cream moisturizer that is specially formulated to relate to your skin type and beauty needs.

TIPS

• Air travel can be extremely drying to the skin, so avoid caffeine and alcohol, and drink plenty of water before flights. If you are traveling to a destination with an extreme climate change, remember to adjust your skincare routine accordingly.

• While breakouts are often associated with external factors, they are actually mostly the result of stress, menstrual cycles, lack of sleep, or diet. If adjusting your skincare routine hasn't solved consistent breakouts, consult a dermatologist.

• It's important to adjust your skincare regimen accordingly as skin matures. It's never too early to take preventive measures against aging skin, such as using an eye cream, and purchasing products with AHAs and antioxidants.

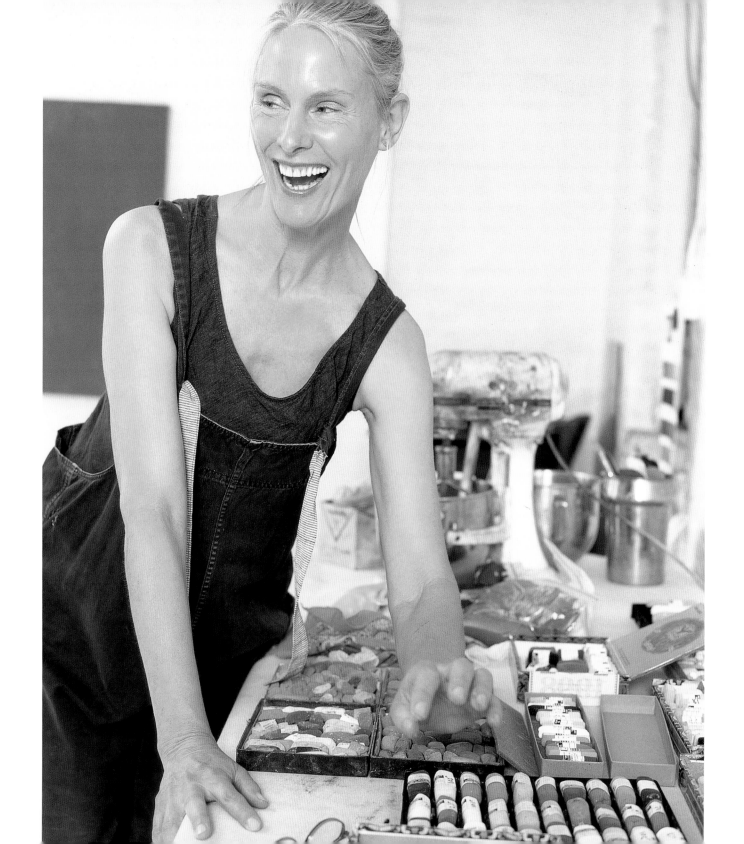

Get This Look: GROOMED NAILS

While trends in nail color and manicure styles have changed over the years—think of the long, rounded talons painted in cotton candy pink, or the square nude manicure or a rogue vamp polish—well-manicured and groomed hands are the basis of any stylish look. Spend some time getting this right, and your hands will never let you down.

STEP BY STEP: HAND CARE

However decorative you get with your nails, starting with a basic care campaign to get rid of sharp edges, hangnails, and overgrown cuticles, and adding moisture will give your hands a good start. Nothing looks worse than hands that are uncared for, so make these steps a weekly treat.

1 Remove any old nail enamel. Soak hands for 5–10 minutes in a bowl of soapy water to soften skin—or more, depending on the condition of your hands. Massage an exfoliating hand scrub into the hands, then rinse and dry gently with a clean towel.

2 Apply a good amount of hand lotion to each hand, and massage it into your skin. Using one hand, massage the palm of the other hand, working the lotion into your skin. Using the thumb of the opposite hand, massage around each cuticle and nail.

3 For an extra-deep moisturizing treatment, apply a thick coat of the cream, or alternatively petroleum jelly, onto your hands. Wrap your hands in gloves or plastic wrap, and leave them for 10–15 minutes. Remove the gloves, and either wipe off any remaining lotion or massage the residue in. Finish by wiping around each nail bed with a clean towel.

STEP BY STEP: FRENCH MANICURE

A manicure is a fun treatment to get or to give yourself, and a French manicure looks "polished" in any situation. Here we have used just a clear coat with white enamel.

1 File your nails to the length that you prefer, and always use a long stroke with the file, because short strokes may damage weak nails. File each nail from the corner to the center, going from left to right and then right to left.

2 Prepare a bowl of warm, soapy water and soak your hands for about 5 minutes to soften the cuticles. Gently push back the cuticle of each nail with a cuticle pusher. If you have any hangnails, trim them very carefully with cuticle trimmers.

3 Rub a towel gently over each nail and around each cuticle to remove any soapy or oily residue. Apply one coat of clear nail enamel, working from the base of the nail to the tip. Let the polish dry completely.

4 Using white nail enamel, paint along the top of each nail, following the natural whites of the nails. This will make the nails appear more pristine and perfect. When completely dry, finish with two top coats of the clear polish to protect the white enamel from chipping.

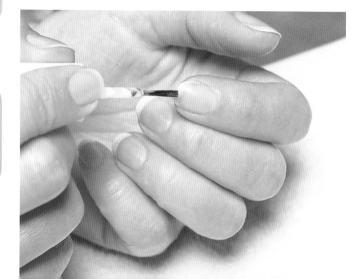

Skincare for Everyone

Skincare is one of the most—if not *the* most—important part of any beauty routine, and it starts from the inside out. Here, you'll find tips that apply to every skin type, but these steadfast rules apply for everyone:

• Get enough rest. Beauty sleep is not just a myth.

• Eat a balanced diet, heavy on fruits and vegetables.

• Drink six to eight glasses of water daily.

• Use an SPF high enough for your skin type every day, whether you'll be directly exposed to the sun or not.

OILY/ACNE PRONE

Use a lightweight cleanser and an oil-free, water-based moisturizer. Toner is essential for this skin type, and should be applied especially on the T-zone.

DRY

WASH THE FACE WITH A SOAP-FREE EMOLLIENT CLEANSER AND USE A CREAMY MOISTURIZER MORNING AND NIGHT.

FAIR/ SENSITIVE

Use hypoallergenic, unscented skincare products. Be careful in extreme climate changes and with spicy foods, and avoid very hot water when cleansing. Use at least an SPF 30 on both your face and body.

MATURE

Use a cream cleanser that tissues off instead of rinsing with water. Try products with active ingredients such as AHAs, vitamins, and minerals. If necessary, use a whitening product to even out skin tone.

COMBINATION

Usually combination skin means an oilier T-zone, so use a toner in this area, and moisturize more heavily on other parts of the face.

julianne moore

eva

star
style

y julianne

eva mendes

JAIME KING

Actress, Revlon spokesmodel

Amber Ablaze, 2002

Guided by trends from the runway, Revlon plays off of the seasonal colors, moods, and textures to create a perfect look to complement the season. Inspired by the arrival of Fall—the first sign of changing leaves, cozy sweaters, and apple cider—Amber Ablaze features intensely rich colors mixed with amber, gold, and copper pearls. These antique tones are showcased in a "fleck" lip gloss and soufflé-like cream eyeshadow. The colors have a new dimension of richness and warmth.

Product information
1. Super Lustrous Lipstick in Amber Ablaze 2. Smooth-On Blush in Blushed 3. Skinlights Diffusing Tints in Buff 4. Revlon Wet/Dry Eyeliner in Coffee Bean 5. Illuminance Creme Shadow in Skinlights 6. ColorStay Overtime Lash Tint in Blackened Brown

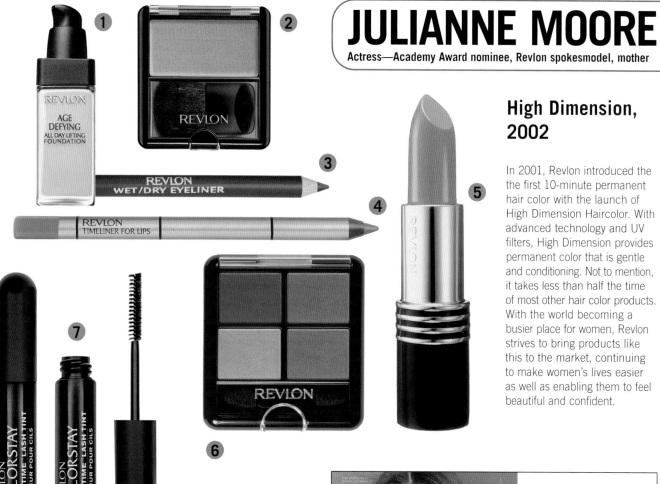

JULIANNE MOORE

Actress—Academy Award nominee, Revlon spokesmodel, mother

High Dimension, 2002

In 2001, Revlon introduced the the first 10-minute permanent hair color with the launch of High Dimension Haircolor. With advanced technology and UV filters, High Dimension provides permanent color that is gentle and conditioning. Not to mention, it takes less than half the time of most other hair color products. With the world becoming a busier place for women, Revlon strives to bring products like this to the market, continuing to make women's lives easier as well as enabling them to feel beautiful and confident.

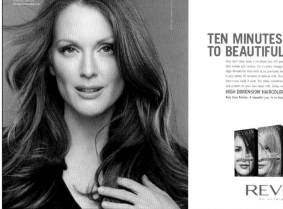

TEN MINUTES TO BEAUTIFUL

REVLON

Product information

1. Age Defying All Day Lifting Foundation in Fresh Ivory 2. Smooth-On Blush in Sandalwood Beige 3. Revlon Wet/Dry Eyeliner in Coffee Bean 4. Timeliner for Lips in Spice 5. Super Lustrous Lipstick in Sandalwood Beige 6. Revlon Wet/Dry Eyeshadow in Coffee Bean 7. ColorStay Overtime Lash Tint in Blackened Brown

HALLE BERRY

Actress—Academy Award winner, Revlon spokesmodel

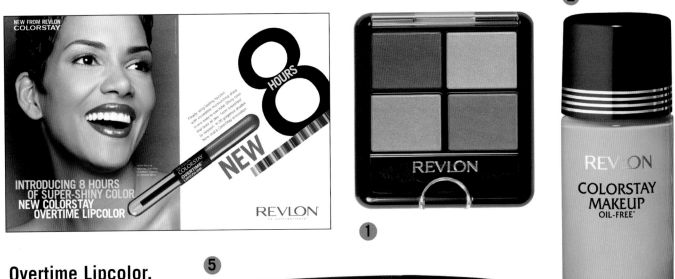

Overtime Lipcolor, 2002

Revlon created this long-wearing category in 1994 and continues to update product formulas to offer consumers the best technology available. Introduced in 2002, Revlon's ColorStay Overtime Lipcolor brings innovative technology to offer up to 8 hours of lush color and shine. While one end smooths on an exclusive liquid color base, the other end brushes on a 99 percent moisture top coat.

Product information

1. Revlon Wet/Dry Eyeshadow in In the Buff 2. ColorStay Liquid Makeup in Caramel 3. ColorStay Overtime Lipcolor in Ultimate Wine 4. Smooth-On Blush in Berry Rich 5. ColorStay Extra Thick Lashes Mascara in Black

EVA MENDES

Actress, Revlon spokesmodel

Product information

1. Revlon Wet/Dry Eyeshadow Quad in Coffee Bean 2. ColorStay Stay Natural Makeup in True Beige 3. Smooth-On Blush in Softspoken Pink 4. Super Lustrous Lipstick in Sandalwood Beige 5. ColorStay Extra Thick Lashes Mascara in Black

ColorStay Stay Natural Makeup, 2003

To meet the rapidly growing desire women have for a "natural" look, Revlon brought ColorStay Stay Natural Makeup to consumers in 2002. With this product, women can now have the extended wear they enjoy from traditional full-coverage foundations, yet still have the natural look they desire. As with all recent launches, ColorStay Stay Natural brings new technology to the marketplace, offering an unprecedented formula that gives women natural-looking, flawless skin for up to 16 hours.

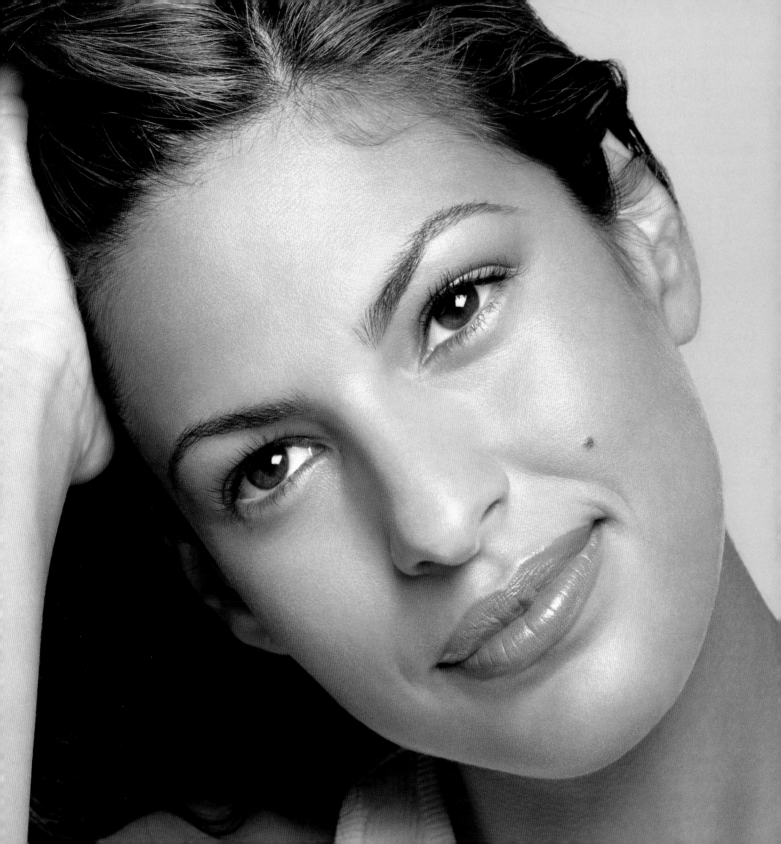

INTERVIEW: A RENAISSANCE WOMAN OF SORTS —FASHION DESIGNER, MAKEUP ARTIST TO THE STARS, AND REVLON CONSULTANT—MOLLY STERN WAS THE MAKEUP ARTIST FOR ALL THE WOMEN FEATURED IN THE COLOR CHAPTERS. HERE, SHE SHARES HER INSIGHTS ON BEAUTY, STYLE, AND COLOR.

What colors do you love to use in beauty? In clothes? In your home?
I love using earthy tones as a base for everything. For example, I have a brown velvet couch, and I wear brown mascara and brown shoes. Then for punch I always go for red. When it comes to my clients I always try to get a feel for them. What colors are they wearing when they walk in? What's in their makeup bag? What colors do they point out from my makeup spread? Color is so personal, and it moves and inspires you.

What were your earliest experiences with color makeup?
I really took makeup seriously. I would play with makeup for hours as a teenager. I loved mixing classic Hollywood with punk-inspired wild looks. My mother is a total makeup junky. She would buy new makeup on a weekly basis, and I was always lucky enough to get the rejects.

How did your beauty regime evolve as you went from beauty civilian to professional?
I cleaned up my act a lot. Toned it down. Sped up the time it took to do it. I always loved doing "real people." It was such a rush to educate the average lady on how to brighten her eyes or fill out her lips. I found that I was really attracted to harsh, shocking looks as a teenager and got more sophisticated as I had more faces than mine to doll up.

Is there something you know now that you wish you knew as a teenager?
That there are really only about fifteen women in the world that look like supermodels, and they are the fifteen women that work as supermodels. That pimples go away and so does baby fat. That time heals all wounds, and that algebra really was a waste of time.

What do you wish more women knew about beauty?
That beauty comes from the heart and soul. That we should enhance our best features, not focus on the ones we don't love as much. That loving and living healthily, breathing and eating well, and dancing and laughing make you more beautiful. That age is beauty, that laugh lines are beauty, that integrity is beauty.

When do you feel the prettiest?
I feel my best when I am rested. Sleep is the ultimate beauty aid. I am not too shabby when my sweetheart is looking deep into my eyes either. Being in love makes me feel the prettiest.

You're such a positive person, emanating ideas and creativity, what makes you the most happy?
First of all, thank you. I am most happy knowing that I am contributing to the self-esteem of women. I love encouraging them to embrace their hips because they are sexy, their dark circles because they are mysterious, their laugh lines because it shows they know how to celebrate life.

Is there a place where you feel the most creative?
The ocean—the intense amounts of colors in the sea drive me crazy. The way the horizon blends with the water, the way the water shimmers… their magic is the most inspiring and creative place on earth.

What do you see as "the next big thing" in beauty?
I pray that there will be a backlash against the plastic generation. That sincerity and beauty will partner again. That age will be celebrated and that flaws and imperfections become the sought-out look.

Do you have any steadfast beauty rules that apply to everyone?
Sleep, healthy diet, a good clean brow, and rosy cheeks.

gotta have it!

By now you've become acquainted with the art of makeup: application, colors, textures, and tools. In this next section you'll be able to familiarize yourself with the actual products we used in the making of the book. Makeup artists Molly Stern and Liza Zaretsky drew from Revlon's extensive line of cosmetics to create sexy, modern, and easily adaptable looks. Each color chapter was designed to offer inspirational ideas, and the products used are made to be mixed and matched, giving you the freedom to experiment and find a look that is 100 percent you. We've included the newest, most updated product assortment, along with our tried-and-true classics. From brazen chartreuse eyeshadow to muted pink blush, and of course Revlon's signature red lipstick, you'll find it all here. So go out, get inspired, and create your own unforgettable look.

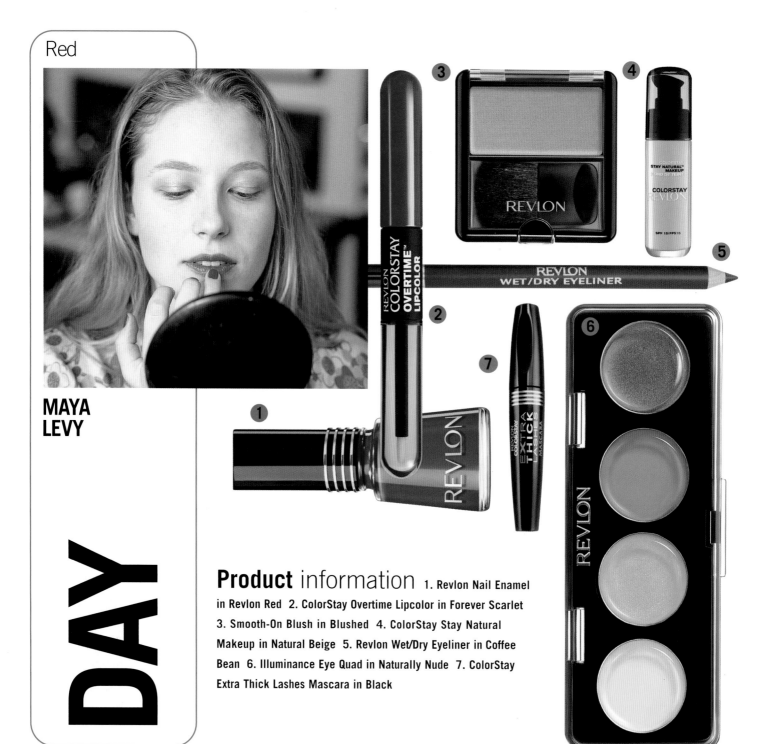

Red

MAYA LEVY

DAY

Product information 1. Revlon Nail Enamel in Revlon Red 2. ColorStay Overtime Lipcolor in Forever Scarlet 3. Smooth-On Blush in Blushed 4. ColorStay Stay Natural Makeup in Natural Beige 5. Revlon Wet/Dry Eyeliner in Coffee Bean 6. Illuminance Eye Quad in Naturally Nude 7. ColorStay Extra Thick Lashes Mascara in Black

Product information 1. Revlon Nail Enamel in Revlon Red 2. ColorStay Makeup in Natural Beige 3. Revlon Wet/Dry Shadow in Silver Lining 4. Smooth-On Blush in Blushed 5. Super Lustrous Lipstick in Certainly Red 6. ColorStay Extra Thick Lashes Mascara in Black 7. Revlon Wet/Dry Eyeliner in Brown 8. ColorStay Lipliner in Red

NIGHT

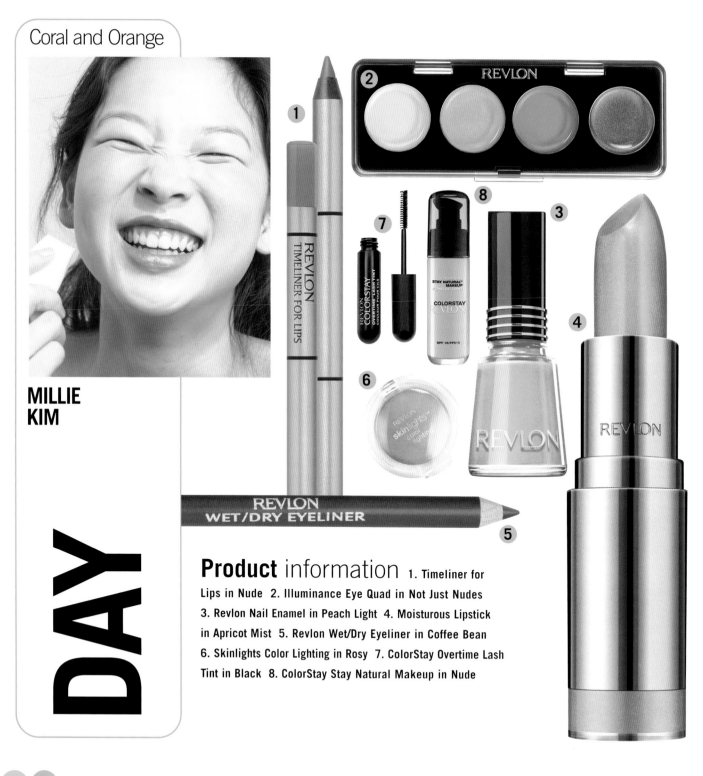

Coral and Orange

MILLIE KIM

DAY

Product information 1. Timeliner for Lips in Nude 2. Illuminance Eye Quad in Not Just Nudes 3. Revlon Nail Enamel in Peach Light 4. Moisturous Lipstick in Apricot Mist 5. Revlon Wet/Dry Eyeliner in Coffee Bean 6. Skinlights Color Lighting in Rosy 7. ColorStay Overtime Lash Tint in Black 8. ColorStay Stay Natural Makeup in Nude

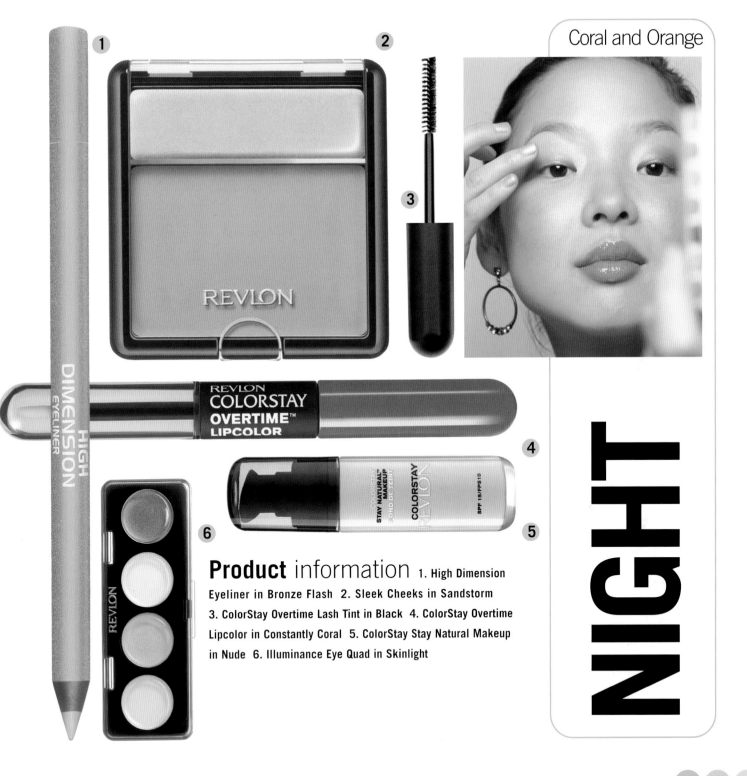

NIGHT

Product information 1. High Dimension Eyeliner in Bronze Flash 2. Sleek Cheeks in Sandstorm 3. ColorStay Overtime Lash Tint in Black 4. ColorStay Overtime Lipcolor in Constantly Coral 5. ColorStay Stay Natural Makeup in Nude 6. Illuminance Eye Quad in Skinlight

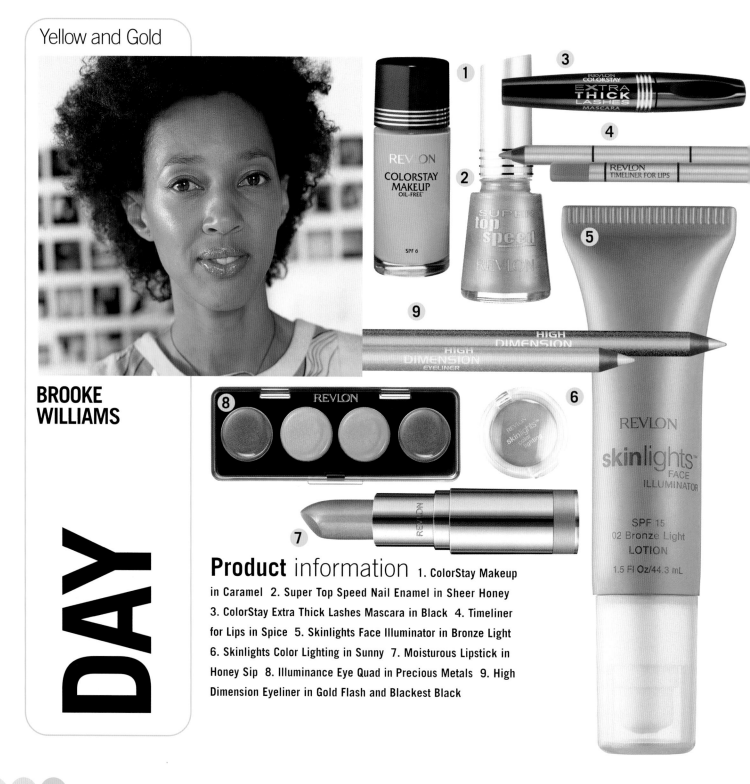

Yellow and Gold

BROOKE
WILLIAMS

DAY

Product information 1. ColorStay Makeup in Caramel 2. Super Top Speed Nail Enamel in Sheer Honey 3. ColorStay Extra Thick Lashes Mascara in Black 4. Timeliner for Lips in Spice 5. Skinlights Face Illuminator in Bronze Light 6. Skinlights Color Lighting in Sunny 7. Moisturous Lipstick in Honey Sip 8. Illuminance Eye Quad in Precious Metals 9. High Dimension Eyeliner in Gold Flash and Blackest Black

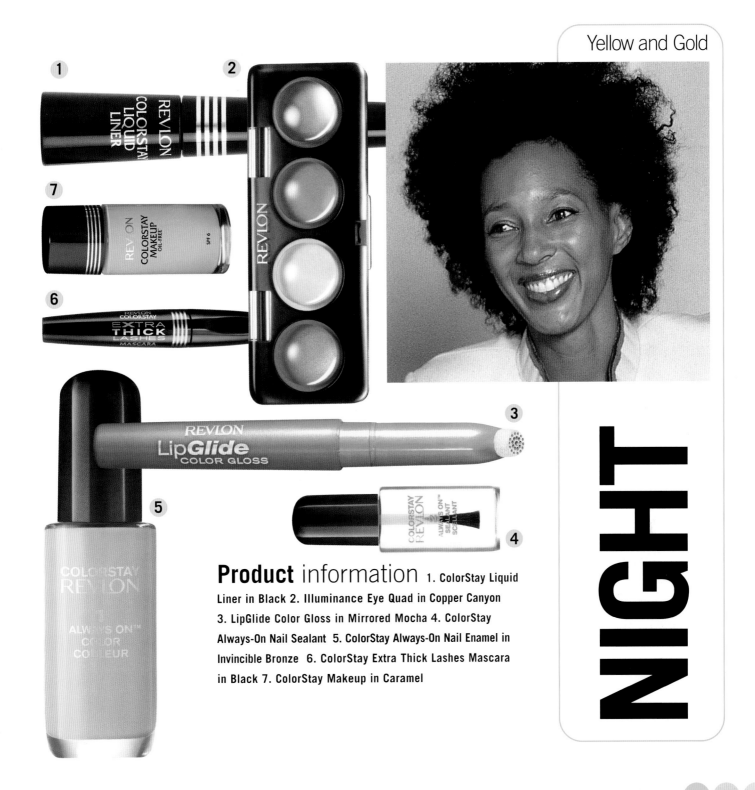

NIGHT

Product information 1. ColorStay Liquid Liner in Black 2. Illuminance Eye Quad in Copper Canyon 3. LipGlide Color Gloss in Mirrored Mocha 4. ColorStay Always-On Nail Sealant 5. ColorStay Always-On Nail Enamel in Invincible Bronze 6. ColorStay Extra Thick Lashes Mascara in Black 7. ColorStay Makeup in Caramel

Blue and Green

**ELIZABETH
SEKLER**

DAY

Product information 1. ColorStay Stay Natural Makeup in Natural Beige 2. Illuminance Eye Quad in SunSparks 3. ColorStay Overtime Lash Tint in Black 4. Revlon Nail Enamel in Sheer Nude 5. Super Lustrous Lipstick in Berry Rich 6. Wet/Dry Eyeliner in Stormy 7. Skinlights Color Lighting in Sunny

NIGHT

Product information 1. ColorStay Overtime Lash Tint in Black 2. ColorStay Stay Natural Makeup in Natural Beige 3. Sleek Cheeks in Skinlight 4. Super Lustrous Lipstick in Naturally Nude 5. Revlon Wet/Dry Eye Duo in Seafoam 6. Super Top Speed Nail Enamel in Tidal Wave 7. ColorStay Liquid Liner in Bronze Brown

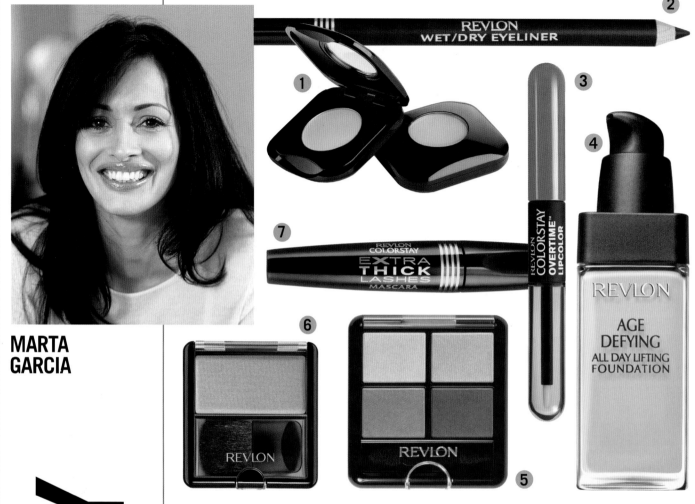

Purple and Lilac

MARTA GARCIA

DAY

Product information 1. Age Defying Concealer in Medium 2. Revlon Wet/Dry Eyeliner in Blackest Black 3. ColorStay Overtime Lipcolor in Endless Spice 4. Age Defying All Day Lifting Foundation in Honey Beige 5. Revlon Wet/Dry Shadow in Violet Haze 6. Smooth-On Blush in Berry Rich 7. ColorStay Extra Thick Lashes Mascara in Black

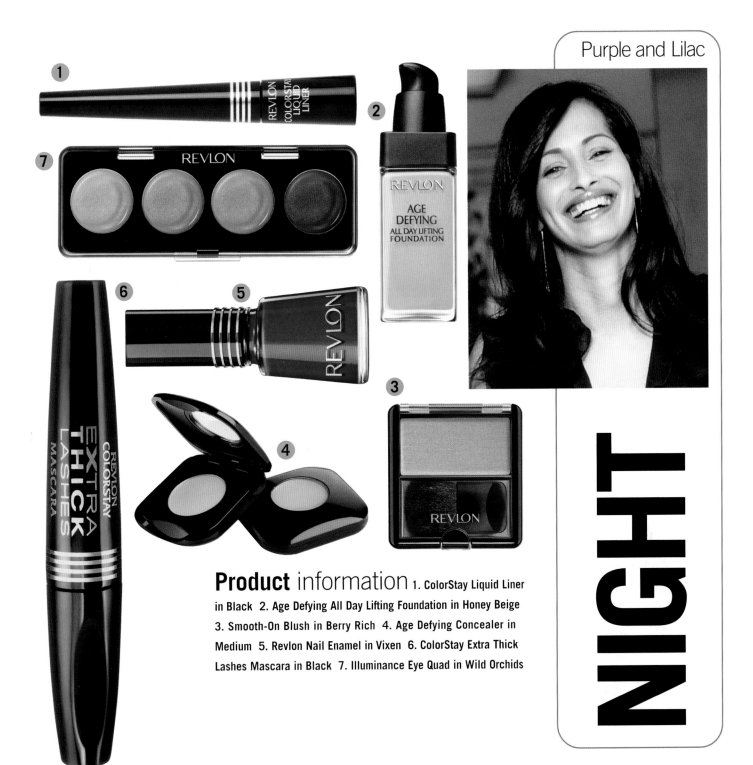

NIGHT

Product information 1. ColorStay Liquid Liner in Black 2. Age Defying All Day Lifting Foundation in Honey Beige 3. Smooth-On Blush in Berry Rich 4. Age Defying Concealer in Medium 5. Revlon Nail Enamel in Vixen 6. ColorStay Extra Thick Lashes Mascara in Black 7. Illuminance Eye Quad in Wild Orchids

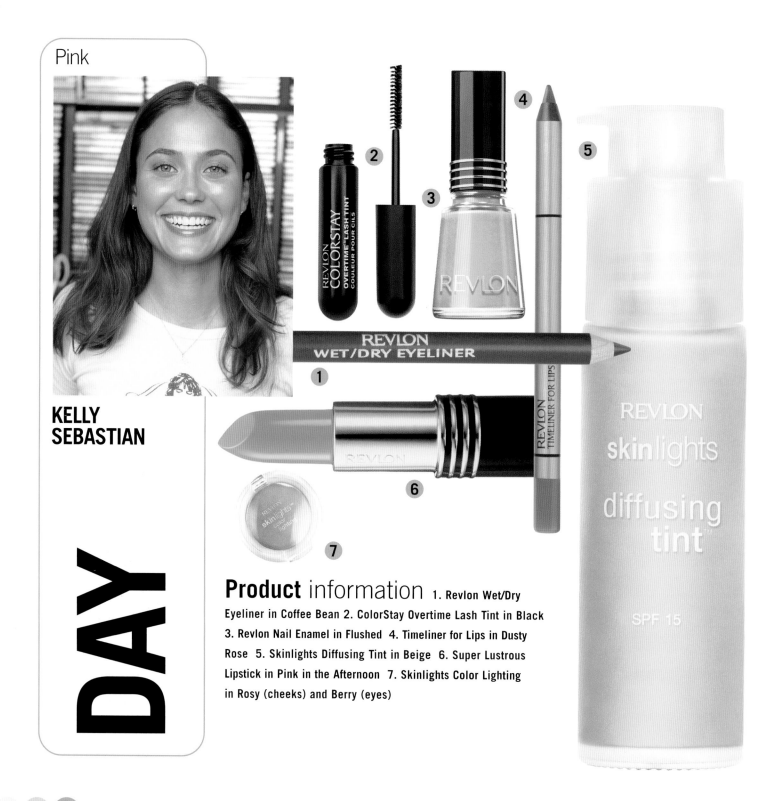

Pink

KELLY
SEBASTIAN

DAY

Product information 1. Revlon Wet/Dry
Eyeliner in Coffee Bean 2. ColorStay Overtime Lash Tint in Black
3. Revlon Nail Enamel in Flushed 4. Timeliner for Lips in Dusty
Rose 5. Skinlights Diffusing Tint in Beige 6. Super Lustrous
Lipstick in Pink in the Afternoon 7. Skinlights Color Lighting
in Rosy (cheeks) and Berry (eyes)

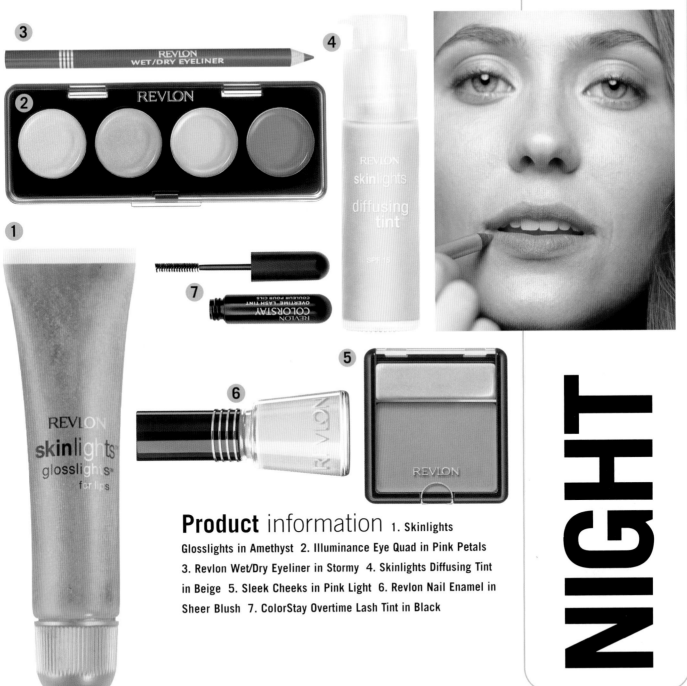

NIGHT

Product information 1. Skinlights
Glosslights in Amethyst 2. Illuminance Eye Quad in Pink Petals
3. Revlon Wet/Dry Eyeliner in Stormy 4. Skinlights Diffusing Tint
in Beige 5. Sleek Cheeks in Pink Light 6. Revlon Nail Enamel in
Sheer Blush 7. ColorStay Overtime Lash Tint in Black

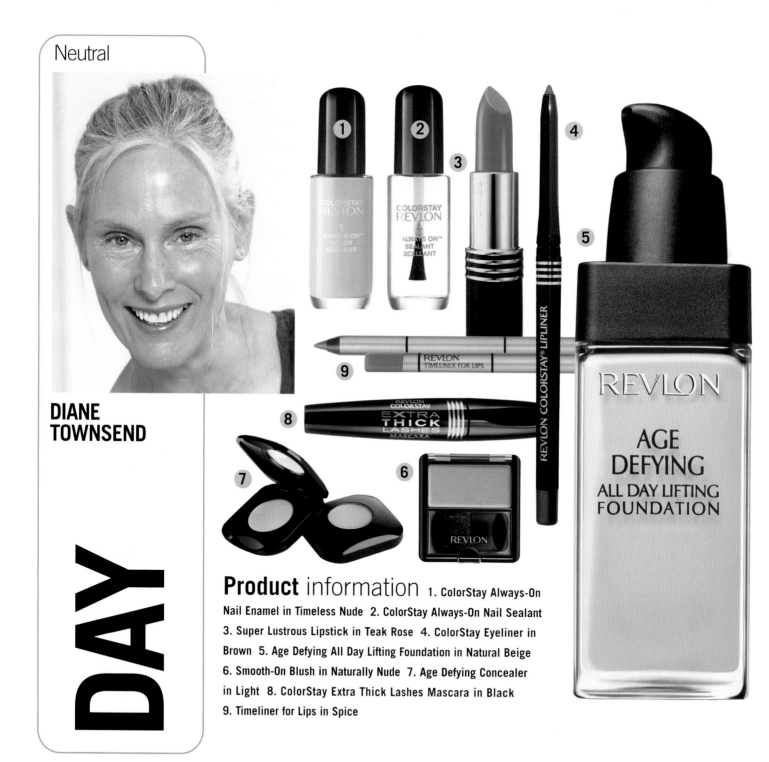

Neutral

DIANE TOWNSEND

DAY

Product information 1. ColorStay Always-On Nail Enamel in Timeless Nude 2. ColorStay Always-On Nail Sealant 3. Super Lustrous Lipstick in Teak Rose 4. ColorStay Eyeliner in Brown 5. Age Defying All Day Lifting Foundation in Natural Beige 6. Smooth-On Blush in Naturally Nude 7. Age Defying Concealer in Light 8. ColorStay Extra Thick Lashes Mascara in Black 9. Timeliner for Lips in Spice

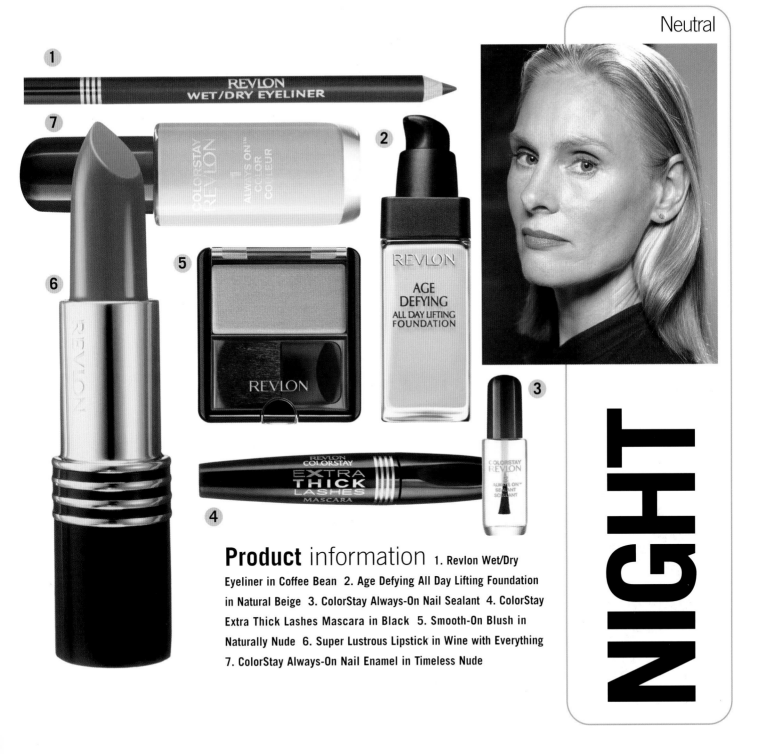

NIGHT

Product information

1. Revlon Wet/Dry Eyeliner in Coffee Bean 2. Age Defying All Day Lifting Foundation in Natural Beige 3. ColorStay Always-On Nail Sealant 4. ColorStay Extra Thick Lashes Mascara in Black 5. Smooth-On Blush in Naturally Nude 6. Super Lustrous Lipstick in Wine with Everything 7. ColorStay Always-On Nail Enamel in Timeless Nude

Index